BRIDGING TIME & SPACE
ESSAYS ON LAYERED ART

Society of Layerists in Multi-Media

Markowitz Publishing

The Society of Layerists in Muliti-Media
was incorporated in the State of New Mexico,
May 13, 1982, Albuquerque,
by Mary Carroll Nelson,
with three directors:
Alexander Nepote, Virginia Dehn
and Martha Slaymaker.

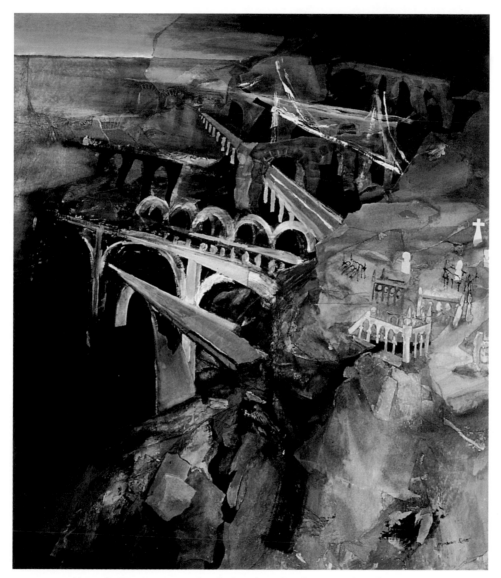

Alexander Nepote,1913-1986, *Bridges Over the Abyss,* mixed media, 70 x 61

BRIDGING TIME & SPACE
Essays on Layered Art

Society of Layerists in Multi-Media
1408 Georgia NE
Albuquerque, New Mexico 87110

ISBN 0-9655890-4-8

Library of Congress Catalog Number 98-067684

First Edition

Published by Markowitz Publishing
Maui, HI

Dimensions of all artwork are in inches, height by width.

Printed in Hong Kong

C O N T E N T S

EDITOR'S COMMENTARY

BY ANN BELLINGER HARTLEY

*R*ichard Newman's *Memory Cabinet* makes an appropriate symbol for the collaborative effort that produced *Bridging Time and Space*. By filling his cabinet with symbols of an individual life as well as the history of all human life, Newman shows that the part can stand for the whole, as in a hologram.

Layered art makes reference to holistic thinking, in which everything is part of a connected web of energy and every aspect of the web is necessary to the whole. The creation of this book has followed a holistic model.

A dedicated editorial team, ten writers, 103 artists and a creative publisher have brought their considerable experience to the project. In a sense, we have filled our collective memory cabinet with the essence of our lives and art, layering our individual contributions to form this tribute to layered art.

I would especially like to thank Susan Hallsten McGarry and Delda Skinner for their time and expertise, as well as our publisher Gary Markowitz. A special thank you goes to Mary Carroll Nelson, who brought us all together for this layered collaboration.

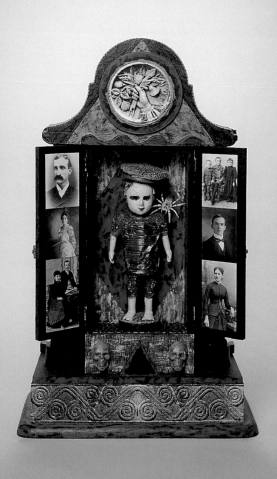

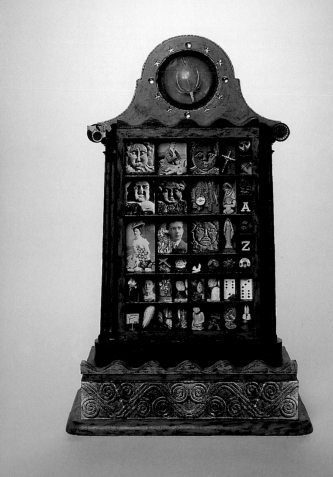

Richard Newman, *Memory Cabinet* (1997), 31 x 18 x 10 *Memory Cabinet*, back view

BEYOND BOUNDARIES

BY RICHARD NEWMAN

*F*or some individuals the term *layering* presents an enigma, a word difficult to relate to artists and their image-making activity. To others, the term can suggest a method so common that it fails to acquire any meaning beyond a technical nature. Surely artists construct their works over time; therefore, materials are applied in successive layers, but understanding the source that shapes these layers of imagery and determines their fusion is another matter. To probe *layering* fully as a cognitive process one needs to engage a deeper view of the creative mind.

I was introduced to the term in the early 1980s when I became aware of a group of artists who operated under the title of the *Society of Layerists in Multi-Media*. Once I began to recollect my own experiences with *layering*, it took on a resonance that metaphorically captured the essence of the creative process. The struggle that I continually confront as an artist

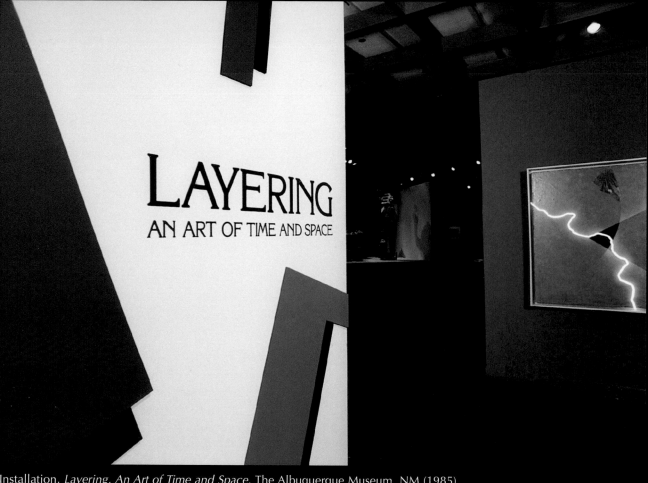

Installation, *Layering, An Art of Time and Space*, The Albuquerque Museum, NM (1985)

Installation, *Crossings*, Bradford College, MA (1994)

involves the need to bridge many levels of perception and layers of knowledge. Every intense creative encounter seems to root out contrary emotions and memories that beg for reconciliation. Not only do contrasting visual elements need to secure compositional unity but the process of achieving wholeness in my work and life has to embrace a recognition of polarity. The act of integration has become synonymous in my mind with *a layering experience.*

By the time I joined the group in 1985, *layering* and the concept of interconnectedness had become a necessary way to think about my relationship to both art and the world at large. Layering as an approach to creative expression recognizes the many dimensions that shape an artist's sense of personal growth and achievement. It articulates a procedure that is equally additive and subtractive as it reaches for completion and authenticity. It also brings into focus how many strata of the

mind one actually taps during the process of conceiving, nurturing and refining a creative idea or product.

The term *layering*, when used metaphorically, can explain the mind's search for both personal and communal meaning. It lends itself easily to an interdisciplinary mindset that draws connections between all domains of knowledge while blurring the edges of traditional media of expression. Essentially, it honors the human quest to reach *beyond boundaries* to make sense of our human condition. Like the two-faced Roman god, Janus, the artist looks both forward and backward in charting his or her own journey in time and space.

This book presents a survey of artists who are motivated both by a need to express their visions, as well as the urge to celebrate their collective spirit. Over the years that The Society of Layerists in Multi-Media has been in existence, members have continually joined together to share experiences and

Richard Newman, sculptures from *Layering, An Art of Time and Space*, The Albuquerque Museum, NM (1985)

Richard Newman, installation, *The Healing Experience*

collaborate as artists. They stand ready to take on challenging projects based upon their understanding of art as a healing force and instrument of social change. Past exhibitions, like *The Healing Experience* (1991) and *Crossings* (1995), both inaugurated at Bradford College, were predicated on the principles of cooperation and open dialogue.

Throughout the years SLMM has sponsored symposia, workshops and annual meetings that have taken place in such diverse locations as Ohio, Indiana, New Mexico, California, Colorado, Maine, Texas, Mexico and England. These gatherings provided opportunities for us to direct our energy toward spiritual awakening and intellectual enrichment. They have also strengthened our personal ties to each other and forged bonds between other professionals or social groups. By sharing our organization's history, as well as our work as artists, we once more send our voices outward like ever expanding ripples in a pond.

If this book encourages you to tap your metaphoric mind and extend your imagination beyond boundaries resulting from convenience and tired habits of thought, then we will have accomplished our major goal. Layering, by our definition, reaches across cultural divides and time barriers to unite the human spirit with the natural environment and the world community, both past and present. A premise adopted by the Society of Layerists is found in the following words of Wassily Kandinsky: "The relationships in art are not necessarily ones of outward form, but are founded on inner sympathy of meaning."

Richard Newman
President
The Society of Layerists in Multi-Media

LAYERING, A HOLISTIC PERSPECTIVE IN ART

BY MARY CARROLL NELSON

*H*ave you ever had a thought that lingered at the edge of your mind, emerging and subsiding so often that you finally had to pay attention to it? The concept of layering came to me in this way, a hint at a time.

By nature and training, I am an observer of and writer about art. When faced with something new, I must learn to see it. In theory, we see what we can believe; likewise, it is easiest to believe what we can see. As our experience and beliefs expand, our vision widens. We become more inclusive and receptive.

Very early in my life I was attracted to works of art that carry hidden wisdom, added levels of information, or mystical symbolism. I studied art history with a passion to discover the inner meaning of art by visionaries of the past. Despite the arid presentation of dates, facts and styles following one another on the screen in a darkened room, I found my lode- stone. I've never stopped looking for art infused with something more than the visual. Such images resonate in my memory. Although my favorite artworks differ greatly, the metaphorical insights they express are related.

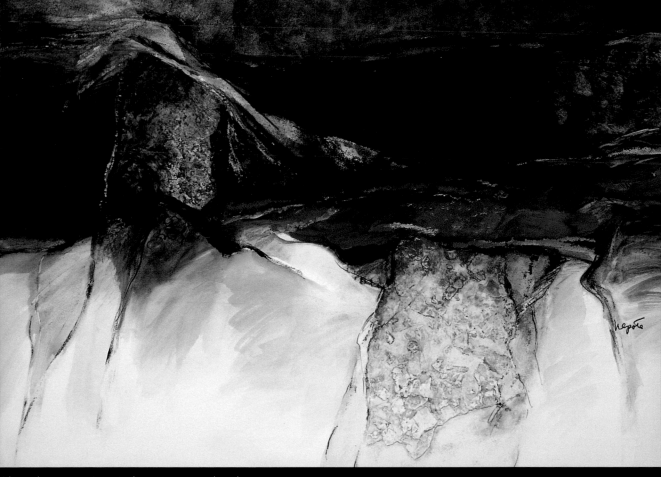

Alexander Nepote, *Layers of Transition*, mixed media, 17 x 23

When I started writing about artists I often chose those who reflected an awareness of "otherness." My desire to find words for their work became urgent. Every so often, I'd get a glimpse of what I was searching for—a feeling, a phrase or a connection—but each time it would slip away. When the word *layering* came into my mind it clarified the subtle similarities in the art I had been responding to for so long. Along with it came *layerist*, which I use to describe certain artists whose work demonstrates a new way of seeing. Around 1974, I focused on layering as a valid development in the history of twentieth-century art.

By the late 1970s, I could summarize the basic premise of layering as an expression of a holistic worldview in which everything is connected through thought, experience and energy beyond any barrier. My formal definition of a holistic perspective is one in which many moments in time connect at one point in space; and conversely, many points in space connect in one moment of time. From the beginning I was sure layering is an art that bridges time and space.

Just before leaving the Bay Area in 1961, I took my patient children to the San Francisco Museum of Modern Art to see an exhibition in black and white. One painting stood out for me, an image of a great rock by an artist who came to be a mentor: Alexander Nepote. We did not meet for 19 years, but I remembered his painting vividly.

In the spring of 1980, I attended Nepote's opening in Scottsdale, Arizona. Without explaining the word, I asked if he would like to participate in a project on layering. His eyes twinkled with understanding. He gave me his card and a positive "yes." That was the beginning of our friendship. I founded The Society of Layerists in Multi-Media in 1982, encouraged by his enthusiasm and active support. He nourished SLMM and served as president until he died in 1986.

Alexander Nepote was the classic Layerist. He expressed his holistic philosophy in paintings of the cliff, which was his sacred image. To Alex, the process of deposit and erosion that formed the cliff reflects the expansion and contraction of the universe itself, the rhythm of the Cosmic Breath. Alex painted, glued,

removed and sanded, building and eroding the surface in a process analogous with nature's to capture *"the Isness of the cliff."*

Alex told me, "It is my personal belief that everything that forms the universe exists as a unity…. The universe has two characteristics: First, it is a whole, and second, it consists of identities connected by relationships." His intention as an artist was to find and express the relationships that exist in the spiritual as well as the material dimension.

The clarity of Alex's thoughts illuminated my own ponderings. I was certain that layering is a true art development, but it is not a label for a style. It does not connote a technique or medium. Layering is an idea, an evanescent as well as a tangible metaphor that imbues art with meaning. Although Layerists make references to many of the same overlapping disciplines in the sciences, philosophy and metaphysics, they are highly individuated and pluralistic in their approach to making art. As they mature Layerists seem to develop a holistic perspective that influences their creativity. It will come as no surprise that I am a Layerist.

Layering is both an intuitive and conscious approach to art-making. Individually, Layerists work out a complex syncretic process. As we move toward completion of a work we layer it with meaning. Despite the wide variation in our work, we have a shared iconography. Our subjects include the geological layers of the Earth; the archaeology of our memories; universal symbols from archaic and tribal art that suggest links with a perceived "mother culture" from which all subsequent civilizations derive; sacred symbols; light as a metaphor for energy penetrating multiple dimensions of reality; the idea that our artwork is a shrine or healing object. Layerists mix materials, make their own paper, hunt for found objects, sew, weave, paint, print, draw, model, form, construct and sculpt, use film, digitalize—whatever it takes to build a harmonious work greater than the sum of its parts. The layer, be it material or referential, is a formal element in the work.

Holistic consciousness pervades layered art with a sense of

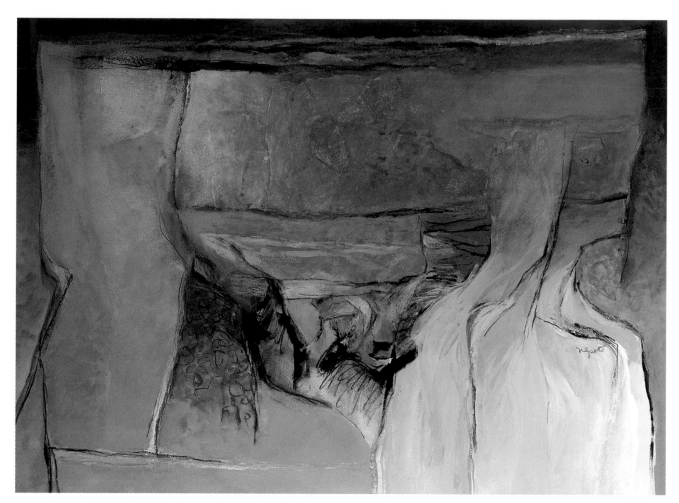

Alexander Nepote, *Sublime Glen*, mixed media, 30 x 40

oneness and a feeling that we live in a multidimensional universe. Adjacent to material reality and constantly impinging on it are other ethereal dimensions. As a model of reality, this picture has spiritual connotations, differing greatly for each person. We become attuned to it in private "aha" moments of déjà vu, insight or unexplainable coincidence.

The twentieth century has been crowded with new thoughts affirming unity. Einstein's theory of relativity, quantum physics, Jung's psychological concepts of the collective unconscious and synchronicity, the Gaia theory, and chaos theory may not be well understood by non-specialists, but their basic concepts filter into the consciousness of all of us.

Artists have responded to expanding consciousness by expressing unifying ideas similar to those that inspired mathematicians, physicists and psychologists. In a rapid sequence of stylistic explorations, they have invented new ways to portray our experience of time and space:

- Cubism, a method of fracturing form to reflect multiple points of view simultaneously, an exercise in relativity;

- Futurism, a way to capture rapid motion;

- Surrealism, an expression of dreamtime;

- Fauvism, an emotional perspective heightened by arbitrary color and animated brushstrokes; and

- Abstract Expressionism, a type of channeling or automatic attunement to one's psyche, combining psychological elements, emotions, rhetorical adherence to intellectual theories, executed by artists who were classically trained—this modality grew from preceding art movements and became the major contribution of American art to twentieth-century world culture.

Artists reflect the viewpoint of their surrounding society. Artisans in the hierarchical, stable world of Ancient Egypt portrayed pharaohs and serfs in a flattened perspective and scale that honored the relative importance of the figures. They did not portray distance. Oriental artists, imbued with the idea that the world is an illusion, created a diffuse aerial perspective. Coinciding with the era of exploration, European artists of the Late Middle Ages and Renaissance slowly perfected linear perspective to convey distance through lines converging at a vanishing point. We can imagine they and their countrymen were tantalized by stories of lands across the sea, beyond the vanishing point on the horizon.

In the late twentieth century, no symbol is more potent than the Apollo photograph of Earth from space. This beautiful "Blue Marble," surfaced with seas and land without boundaries, patterned with clouds and shadows, has altered our visual perspective forever. I believe this picture marks a change in human consciousness and signals the appropriateness of a holistic perspective to a new age of inner and outer space exploration.

Since founding SLMM I have watched with wonder as the concept of layering widens and deepens. Each member brings to the group an individual interpretation of holism. Through a reciprocal exchange the SLMM network continues to respond innovatively to its own energy.

I compare the shared energy rippling through our creative imaginations to a humming sound. This subtle vibration is especially perceivable in SLMM's exhibitions.

The book you are holding is an exhibition by Layerists. If you sense the unity within the diversity of their work, these images might become a persistent memory lingering at the edge of your mind.

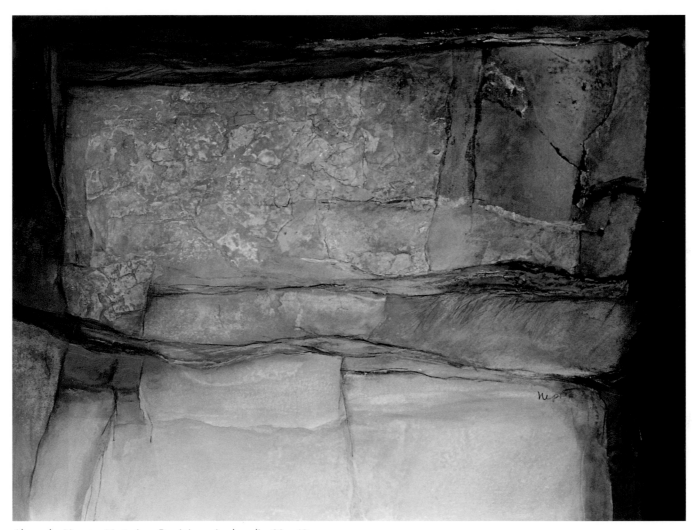

Alexander Nepote, *Mysterious Precipice*, mixed media, 30 x 40

ALCHEMY OF
A CREATIVE IDEA

BY MARILYN HUGHEY PHILLIS

*A*lchemy! That magic word! One of the definitions of alchemy is the "process of transmuting a common substance, usually of little value, into a substance of great value." Medieval wizards were discredited for failing to transform their metals into gold. But is gold the only thing of value? Compare alchemy to the creation of visual art. An artist combines simple materials to create artist's gold, an expressive visual statement, a whole greater than all of its parts. The creative transmutation of ideas, materials and spirit seems to be particularly apparent in *layered* art.

The basis of alchemy is the notion of process. In the creative process that has true alchemistic properties, there is a fusion of these elements: the selection and manipulation of materials and, most importantly, the expressed passion and joy of the artist's spirit during the creative act. Ego is set aside. Emotion is high and playful. Time disappears. Creative magic is fully realized. When this transmutive combination is present, it captures the wondrous transition from the nucleus of inspiration to mature statement.

Above: Susan C. Boyes, *Handsome II*, porcelain & fiber, 13 x 3

Left: Venantius J. Pinto, *Truth 5 (Sathyag)*, watercolor & print/paper, 22 x 16

Margaret Alderson, *Heart of the Oak*, acrylic/textured paper, 21 x 29

In science we observe the metamorphosis from cocoon to butterfly, fertilized cell to human form, mass to energy. Such changes have predetermined results. The artist, relying on an individual conduit of communication and revelation, creates through an evolving process leading to the unexpected.

Creativity occurs through a holistic psychosomatic process that affects each artist by enhancing life energy and enriching the psyche. The artist transcends achieved technical ability and reaches for a higher conceptual level, becoming the explorer who dares to go into the unknown. Some of the artists in this book have experienced that unforgettable phenomenon.

Susan C. Boyes, an art therapist from Albuquerque, New Mexico, works in porcelain. Though highly accomplished in the traditional Japanese style, she began to question her use of a technique from a different culture. She wondered what she could take with her of these traditional foundations into the exploratory process of art/living?

Boyes says, "Studying my art is a way to track where I've been, where I am and where I'm going. Artistically, I wanted to stretch the capabilities of the material and of myself." She feels that "stimulating creativity in one area also stimulates creativity in other areas of life." She compares a breakthrough creative discovery to an archaeological dig that helps her get to the very "bones of an idea." The striking simplicity of her porcelain creation *Handsome II* belies the complexity of the search that led her to this transmuted form which reflects both the Oriental influence and her own distillation of purpose.

New York artist, **Venantius Joseph Pinto**, a native of India, is a philosophical artist who seeks to "bring out the energies manifest in ideas." By means of computer technology, he

Mary Ellen Matthews, *Little Shorty* (Artist Book), split leather boot, xerox transfer on silk, thread, rubber stamp, Coptic stitch binding & artist-made paper, 13 x 11 x 2

expresses with fragments and wholes "a flow of relationships and events stemming from an evolving archaeology of my existence that began in India. I use color as discrete units of energy. Layering is my metaphor to express notions of the memory of time, the deity, culture, power and compassion, and my unfurling Christian existence amidst myriad religiosities. I bring these elements together in a mandala of layering."

Pinto's *Truth 5 (Sathyag)* is part of an eight-piece series. Although the background was created in stucco at a construction site in New York, the markings reminded him of cow dung applied by hand to earthen floors in Indian villages. Such correspondences reinforce his perceived connection within a "boundless spiritual womb."

Margaret Alderson, who is the founder of the Torpedo Factory in Alexandria, Virginia, where she has her studio, is a watercolorist. She is attracted to powerful manifestations of nature, particularly the mystery embodied in old trees. In her *Heart of the Oak*, twisted, time-wizened trunks and limbs reach out to the sky, symbolizing our need to cherish the environment. Here, in the sense of alchemy, the heart of the tree stands for the heart of nature, possibly our own heart or the heart of the whole earth. Although Alderson describes her art straightforwardly, she is completely involved with her subject and the qualities of light surrounding it as they take visual seed upon her paper. She says that creating a painting is a "coordinated effort involving the eye, hand and heart." The palpable texture of the surface and the layered color enrich the form and deepen the emotional impact of her painting.

Mary Ellen Matthews, a San Antonio, Texas, artist, explains that "The seed of an 'artist book' begins to grow in my head long

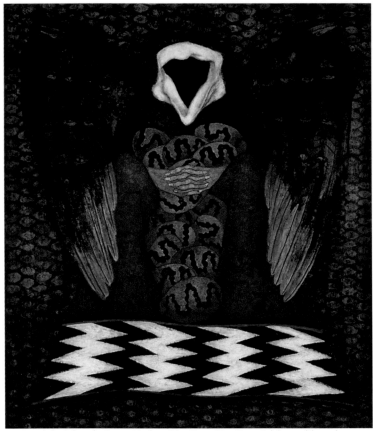

Meinrad Craighead, *Crow Mother, Her Eyes, Her Eggs*, ink/scratchboard, 16 x 12

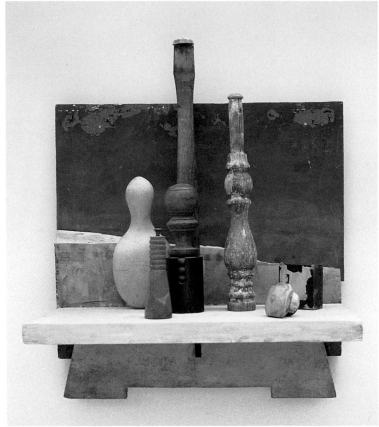

Pat Cox, Shelf Life, *Figures in a Landscape*, wood, metal, paint & found objects, 15 x 11 x 6

before it becomes a reality." She nurtures the idea and the concept begins to take a form and size, a particular shape and binding. "The visual images and text flow together giving the book pages their own intrinsic character. The stages cannot be forced and there must be a natural flow of ideas meshed with image and material."

Matthews made her book *Little Shorty* by cutting a leather boot in half and attaching the handmade paper pages between the boot sides. She created the book as a humorous gift for her husband, Dan, to remind him of his Texas boyhood days when he spent hours pretending to be a cowboy practicing his draw. In 1997, Dan Matthews underwent long sessions of treatment for cancer. The book's purpose was to add the elixir of humor to his medical care.

Meinrad Craighead lives beside the Rio Grande River in Albuquerque, New Mexico. Working in ink on scratchboard, she brings forth spiritual images from her dreams and meditations. By intricately weaving language and image into a tapestry of line and color, she creates a "sacred union of spirit and nature." In her *Crow Mother, Her Eyes, Her Eggs*, the wise crow "with eyes all knowing and body productive" serves as a metaphor for our journey into the mythological truths of the soul. Meinrad adds a mysterious comment: "We may see the carrion Bird Goddess of Western antiquity, She who eats Death and rebirths Life, as our own Crow Mother. Her face is an impenetrable void. She lays the eggs of potential in each of us."

Pat Cox, of Palos Verdes Estates, California, uses "discards and secondhand materials as metaphors to trigger memory and

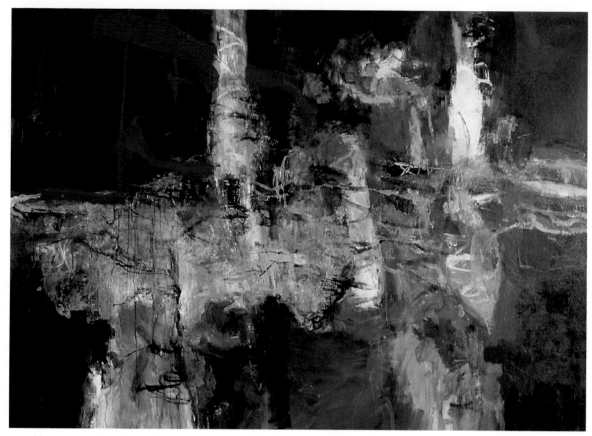

Harold E. Larsen, *Meet Me in Paris*, acrylic/canvas, 50 x 60

emotion." Unpredictable materials, through their beauty, mystery and power, allow her "to explore the transformative possibilities of found objects through combination, alteration and juxtaposition." Cox feels that these used materials whisper of lives past, now given a chance "to play a new role."

In her *Shelf Life--Figures in a Landscape*, one of a series, Cox explores a variation of the traditional still life by combining "ordinary objects in place of the usual flora, fauna, fruit and tableware. The relationship of these cast-offs with one another— the resonances that occur between them and how they occupy space—becomes the artwork.

Santa Fe artist **Harold E. Larsen**'s *Meet Me In Paris* is an interplay of dark, light, movement, line and complex color-laden shapes painted in layers of acrylic on canvas. He feels that matu-rity gives him the freedom to express the periodic turbulence of the past, when some doors have closed and others opened, and it has brought him spiritual power to face the future. "My paintings are as much a statement about how I am now as they are about what I see. Darkness is important; it allows the glory to shine more." Larsen accepts his work as a portrait of his spiritual being and becoming. Within ever-changing complexi-ties of line, color and form, he creates a sense of boundaries disappearing. He says, "It is my goal that people find a mirror for their journey and wonderment of life through my paintings."

Layered Passages by **Anne Cunningham**, a Raleigh, North Carolina, artist, is a combination of brass, paper and found objects. While working as an interior designer, Cunningham discovered she could personalize spaces by adding her own art,

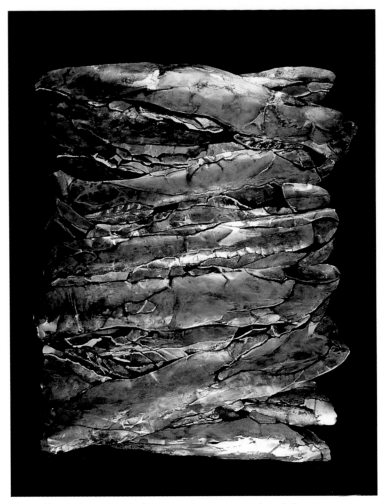

Anne Cunningham, *Layered Passages*, brass, papers, found objects, dyes & inks, 42 x 32

gel medium. She describes her unusual woven, multicolored work as "powerful yet sensual pieces inspired by nature, science and images from my life." The results are spectacular, having the feeling of antiquity, of earth processes at work and the artist's hand bringing it all together in an integrated form of alchemy.

Iku K. Nagai, who lives in the Bay Area of Northern California, presents the dramatic tension of the *Blue Nile* through her vigorous, complex linear passages, as well as delicate subdued elements. Nagai is a master of gestural calligraphy that carries potent emotional energy. In contrast, she renders the atmosphere of ancient mystical landscapes with broad abstract collage-like forms. She makes distinctive use of gold leaf and pure mineral pigments.

The Nile, where seven thousand years of Egyptian civilization has flourished, was the inspiration for her painting. She feels the work is a "subjective transformation of my humanistic cultural consciousness, interpreted in a contemporary abstract expressionist form." With our inner eye we interpret her dynamic forms as the imprint of the river's natural and human history. The painting invites continued exploration.

Dianne Reeves, of Austin, Texas, created *Seizing Penumbra* from cow ribs, found materials and paper, to depict a journey into the "encasement of the shadow area in life." In astronomy, penumbra is the area between full illumination and full eclipse. Reeves' theme is free speech. She says that, "even though we, as a country, are allowed freedom of speech, the opinions expressed can be without full knowledge of the subject The listener must wade through the words ... and ultimately formulate a correct deciphering of information."

Douglas B. Stone describes Reeves' work as inviting the viewer's "immersion in her textural world ... the structural paradoxes she creates, implications made real by insights both into feelings invoked and images reworked." Reeves says of her multimedia book, "You are unable to see forward because shadows suppress what is really taking place in daily living, preventing an all around view of life The ultimate shadow is yourself."

which in those days were functional pieces. That path led to experimentation and to the contemporary work in light metals that she does today.

For a change of texture and color, Cunningham wields a propane torch and treats the surface with chemicals, color dyes and black or white ink. She builds up works to large scale with additions of handmade paper and natural objects embedded in

Left: Iku K. Nagai, *Blue Nile*,
dry pigments & gold leaf/paper, 41 x 51

Below: Dianne L. Reeves,
Seizing Penumbra, handmade dyed
abaca paper, bones & test tubes,
12 x 30 x 15

Terry Gay Puckett, *The Juggler*, mixed media/Mexican bark paper, 22 x 15

Terry Gay Puckett drew on her experiences in Mexico as well as her life in San Antonio, Texas, when she created the demonstration piece, *The Juggler*, while pulling scraps randomly from her collage bag. Those scraps brought up memories and some regrets. "The small blue figure in the lower part of the collage initially represented 'the Child Within,' a recurring theme in my recent work. But the child figure began to change, tossing her gold balls into the air. The act of juggling became a metaphor for needing to balance responsibilities amid the frustrations of daily pressures and relationships. I realized that The Juggler was me, and 'the child within' was trying to cope. I felt satisfaction with the aesthetically pleasing balance achieved on paper, even if it isn't always possible in everyday life."

I see what appears to be a larger figure, possibly an Oriental female, behind the small child. Could this archetypal component represent complexity and balance?

The search for the beauty and mystery of the unknown is an integral factor in the human journey. For me, both science and art act as strong influences on my creative explorations. As an artist, I search beyond the surface aspects of subject and design for the elusive but powerful spirit that transcends all dimensions. A work of art speaks most powerfully when spirit is retained within the embodiment of created form. If soul and passion are added to a painting, the image soars. It speaks from the heart and to another's heart. This is communication at its deepest level.

An influx of spirit affects many of the works you have seen in this chapter. I sensed its arrival as I worked on *Grand Finale* in my studio in Wheeling, West Virginia. While I was in a meditative mood, I began painting intuitively, laying great sweeps of watercolor in a dance of implied shapes. I was completely caught up in the joy of the moment. I have come to appreciate the true importance of process. It is the purest kind of play. As I enriched the shapes with thin layers of acrylic color and texture, the painting seemed to become a journey into the depths of the cosmos, providing me with one grand revelation after another. These moments are rare, but unforgettable for an artist. They encourage the ever-revealing voyage we all are challenged to take in our work. The creative process is alchemy.

Marilyn Hughey Phillis, *Grand Finale*, acrylic & watercolor, 30 x 40

SPIRITUAL ESSENCE

BY DELDA SKINNER

*H*ave you ever walked into a gallery or museum, rounded a corner, looked up and been transfixed by the artwork confronting you? I have … by Monet's *Water Lilies*. You cannot move, you cannot breath. Chills run over your body, and you don't know whether to laugh or cry (I usually cry), and you enter another time and dimension. Your spirit soars, you experience an interior transformation that is euphoria and ecstasy-pure joy.

Does this happen to you when you hear certain music? It does to me when I hear Pavarotti sing Puccini's *Nessun dorma*. I am the music, or, when seeing the *Water Lilies*, I am the painting.

As a painter in the midst of a painting, I enter *the zone* without realizing the moment of change. Hours later when I re-enter myself, I am amazed to find I have painted the best painting of my life. All of these aesthetic experiences are spiritual in nature. Verbal definitions are inadequate. You must feel this essence with body, mind and spirit.

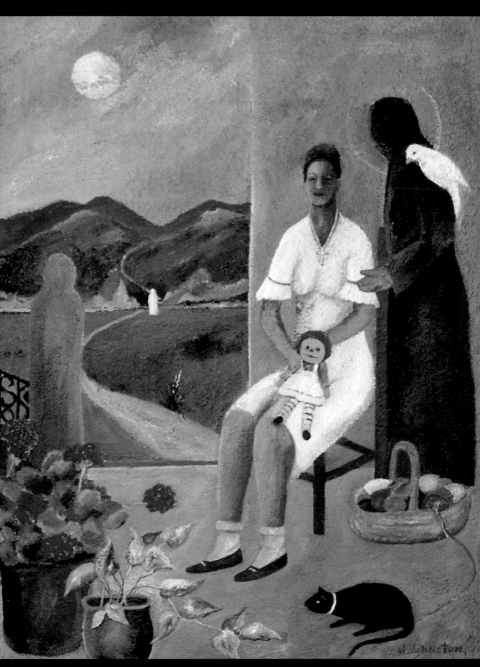

June F. Johnston, *Death Trilogy, Part III (Rachael)*, acrylic & mixed media, 48 x 36

Beverly Goldsman, *The Initiate*, mixed media, 14 x 11

Once experienced, knowing the spiritual is immediately recognized in the very center of your being. This simpàtico between you—as viewer, hearer or maker—and the art forms a deep and integral relationship. You feel a complete understanding through your senses. You are at One with the object of your experience, and it will forever be imprinted on your consciousness. As Mike and Nancy Samuels write in their book *Seeing With the Mind's Eye*, "All we see are our visualizations. We see not with our eyes, but with our soul."

At that moment of seeing you are changed; maybe not greatly, there may not be an awareness of change, but forever more, there will be a new knowing within you. The dross has been burned away. Pure knowledge remains.

Puccini said, "The great secret of all creative genius is that they possess the power to appropriate the beauty, the wealth, the grandeur and the sublime within their own souls, which are a part of Omnipotence, and to communicate those riches to others."

We all yearn in this information age, for deeper, more intimate and personal relationships with our world. Lawrence Leshan and Henry Margenau capture this thought in their book *Einstein's Space and Van Gogh's Sky*, "Art can let us know that we are not alone with our perceptions, that others also see things as we do. We differ from others and each of us is unique and therefore to some degree, stands alone in the universe he constructs. A warm arm has reached out of time and distance to us and has let us know that we are not alone, that others live in the world and see it as we do. The artist has repeated to us the message of Plotinus, 'None walks upon an alien earth.'"

We, indeed, are all in this together. Past, present and future are all connected, and soul speaks to soul deep in the collective unconscious. We discern this to be the hard-pan—the bedrock of our lives as artists. Willa Cather writes, "Artistic growth is more than anything else a refinement of the sense of truthfulness. The stupid believe to be truthful is easy, only the artist, the great artist (*any artist*) knows how difficult it is," (italics added). Sister Wendy Beckett shows us the spiritual implications of an

art of truthfulness when she says, "The mind may be aware only of the impact of some mysterious truth. This is the essence of spiritual art. We are taken into a realm that is potentially open to us, we are made more what we are meant to be. All great art, being spiritual, both grieves and celebrates what we do."

The pathos of this is seen in the poignant memorial to her mother, *Death Trilogy Part III, Rachael* by **June J. Johnston**. You are immediately drawn into the scene, not as a viewer, but as a participator who will accompany Rachael on her final journey. Johnston, who lives in Watkinsville, Georgia, has surrounded her mother with symbols that reflect her life: the flowers, cats, handwork and the Raggedy Ann dolls she collected. The doorway and path are not only integral to the design, they also support the spirit of pilgrimage in the painting. Rachael's deep religious faith is evident in the cross she is wearing, the death figure with the nimbus and the dove. The shaman-like sentinels are placed to show Rachael and us the Way.

Beverly Goldsman's collage, *The Initiate*, makes you conscious of the inward state of the figure in the lower part of the artwork. Goldsman, who lives in Buffalo, New York, says that "the young initiate, bare-chested and shorn of hair, sits in darkness. His eyes are closed and his head is raised upwards. He is willing to give all his being in exchange for 'the truth.' Above him is a scrap of holy text covered with a small shard of amber glass. It provides the only color in the collage. Four older holy men are discernible. They have preceded the initiate in *the search*. He hopes they will guide him, that they will teach him to go beyond language and to accept the flow where he will find a sense of peace and joy in feeling one with all. He is on the Path."

G. K. Chesterton reminds us, "We have forgotten who and what we are and art makes us remember that we have forgotten." In *Return* by **Mary Hughes**, the Claremont, California, artist helps us remember who we are both collectively and personally. Her childhood memories and search for wholeness are the impetus for the painting. Through the metaphor of the eyeglass, she refers to her philosophical and

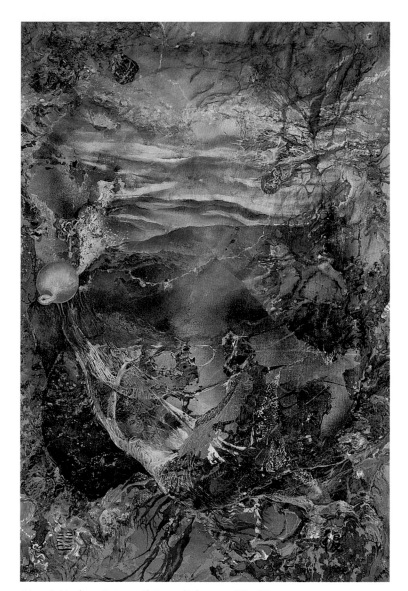

Mary F. Hughes, *Return*, oil & acrylic/canvas, 53 x 35

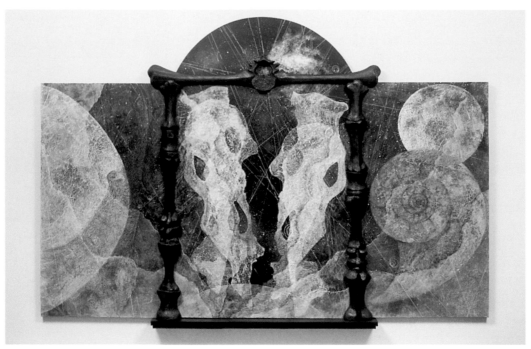

Georgette Sosin, *Ancestral Gateway*, mixed media, 56 x 80

spiritual search of her multilayered experiences, which she expresses through an infusion of symbols from world religions. *Return* speaks eloquently to all with "eyes to see," with the message that there is an on-going life process of outward-reaching freedom, symbolized by the woman in the hammock, and inward knowledge of truth, symbolized by the blue dwarf star and the rock with gold strata. The movement within the painting reminds us of our own cyclical formation, when awareness is learned, forgotten and then relearned.

The symbol of life as a journey on our own individual paths is used superbly in Houston artist **Ann Bellinger Hartley**'s collage, *Road to India*. The handmade paper frame with the house shaped opening implies Hartley's basic belief in family-centeredness. The frame is embossed with circular, linear and gridded symbols to indicate the diversity in unity. Multicolored fibers taken from a fragment of antique weaving, suggest strands of life that are woven together, forming mysterious and lasting bonds for the journey through time. Buttons hold things together, the way love and understanding fasten relationships

into a solid fabric. The printed and stamped paper and cotton materials are folded and overlapped as the many layers of experiences are intertwined. Francis Bacon asserts that "The job of the artist is always to deepen the mystery." For Hartley, India represents the exotic and the mysterious-hence the title of her work.

The symbolism of a journey continues in the mystical, mixed-media painting, *Ancestral Gateway*, by **Georgette Sosin** of Chanhassen, Minnesota. The triptych is a metaphor that stands for the passage between realities. As we pass through we experience a spiritual awakening to the knowledge of our interconnectedness with the earth and the universe. The intriguing, sculpted bone gate represents our ancestors, human and animal. Sosin explains, "Their wisdom leads us through the archway to our journey." The image of the eagle, messenger of the spirit, and the shell, representing our watery planet, along with the split skull are used to denote the great energy released into the universe. The movement and limited color in Sosin's artwork contribute to our feeling that it holds an unseen depth of meaning. We are taken out of ourselves into transcendence.

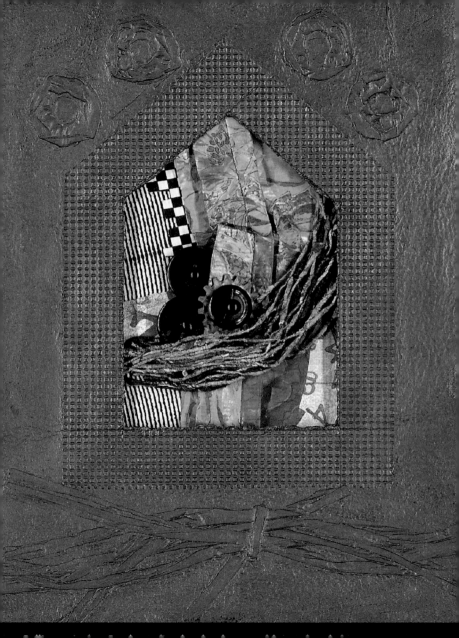

Shirley C. Barnes, *The Blessing*, acrylic/canvas, 48 x 36

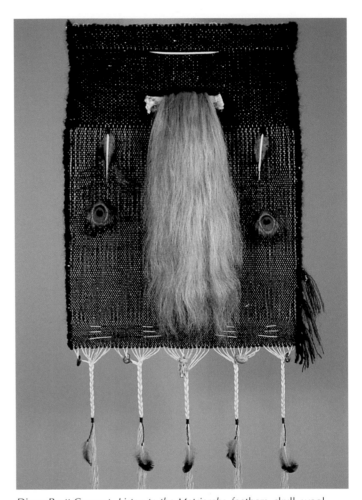

Diane Brott Courant, *Listen to the Matriarchs*, feathers, skull, wool, linen, hair & fossils, 42 x 18

As Dame Janet Baker said, "We all have a gift to give, and if you give it with a sense of holy obligation everything clicks into place." **Shirley C. Barnes** brings her gift to the reverberating forms and colors of *The Blessing*. As your eye travels the wonderful shapes in the painting, you realize you are seeing figures with outstretched arms, ready to give and receive. They symbolize bringing opposites into relationship. Barnes, from Huntsville, Alabama, writes, "When these two figures stand back to back, they are brought even closer by the stream of golden color that pours from above and weaves down their backs to connect at the center. From below, two earth colored shapes hold the figures in balance. Their color and weight give credence to a consciousness made manifest. The stroke of turquoise with its companion shadow angles across the earth to reach the ethereal violet and there is a touching of soul and spirit. Color and form move across the canvas blending, weaving and layering, bringing a pattern of meaning-the anointing of opposites in a blessing."

Diane Brott Courant of Belfast, Maine, writes about her hand-woven wall hanging *Listen to the Matriarchs*, "This

Rochelle Newman, *Ezekial's Wheels*, acrylic & weaving, 22 x 30

artwork is born of my desire to honor my older women friends. It embodies the qualities of gratitude and benediction. The long fall of human hair was inherited from a friend and teacher. It hangs from a sheep bone I found on Russ Island, when another older woman friend was being honored for donating the island to the Nature Conservancy. The regal dark purple mohair and wool mixture is the favorite color of yet another older supporter. Peacock feathers have long symbolized authority and power. The fossils and squirrel skull at the base of the hanging point to longevity and intimations of mortality, the natural philosophical habitat of seasoned female knowledge/wisdom. Now that I have become a matriarch, there is a new layer of meaning woven in."

Rochelle Newman's *Ezekial's Wheels* is a powerful experience for the observer. The movement within the painting is palpable and one can easily see the correlation between her painting and the Biblical Ezekial's wheels. It reminds me of the old song, "a wheel within a wheel, way up in the middle of the sky." Newman, of Bradford, Massachusetts, manipulates the two-dimensional surface to visually suggest many dimensions. For her, spirit is found within the ideas that she responds to emotionally.

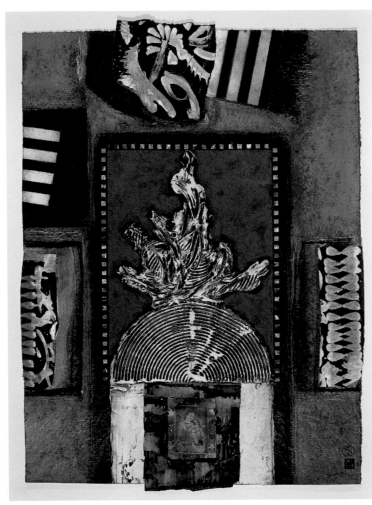

Stanley G. Grosse, *Shrine Series-Retablo II*, mixed media/cotton paper,
37 x 27

She is fascinated with archetypal geometric figures and forms. With the primary triad-yellow, red and blue-as well as complementary color pairs, she expresses the strength of union and the tension of opposites. Figure/ground/image/space/positive/negative tension are her meta-phors for interconnectedness and the balance of polarities. Light figures strongly in her work. She writes, "Light illuminates space. Light is the essential oneness of the spirit. It is without physicality until it is broken up into color by the prism of existence. Light in its diversity becomes color. The infinite is made finite."

"Imagination is more important than knowledge," said Einstein. **Stanley G. Grosse**, now living in Scottsdale, Arizona, is one of those fortunate few who have both gifts, as he demonstrates in his *Shrine Series-Retablo II*. The painting is universal in scope. "My subjects are shrines, totems, monoliths, patinas, skies, wind and water, geological outcroppings, man and man's markings on his environment. To them, I feel a deep homage," Grosse says. Shrines from all over the world fascinate him. Here he combines the Retablo—a painting of a saint as seen in Southwestern Hispanic art-in the lower part of the work with Oriental shapes at the top and sides that balance and frame the vibrant central passage. The black and white spiral or labyrinth has many symbolic connotations such as: birth/rebirth, death/resurrection and growth. The spiral has been known in diverse cultures since men made their first marks. Another universal emblem is the flame-like image at the top of the spiral which refers to the idea of purification by fire.

To me, **Delda Skinner**, of Austin, Texas, all art is spiritual. I like this quote by Leonard Shlain from his *Art & Physics*, "The artist holding a brush, whose spiritual attainment is such that he holds it as though not holding it, imparts to the brush the soul of his creative spirit." In the process of painting *Dialogue*, I thought and felt the many messages that come to me through the spirit. I feel that this is a universal dialogue and language; so, I created my own symbolic alphabet for this many layered work. I have interlayered-and not entirely revealed-irenic blessings, prayers, names and invocations to strengthen the outreach and energy in the painting. I paint openings and vague landscapes to emphasize our journey through time and space—we are the earth, we are the stars-we are within the All.

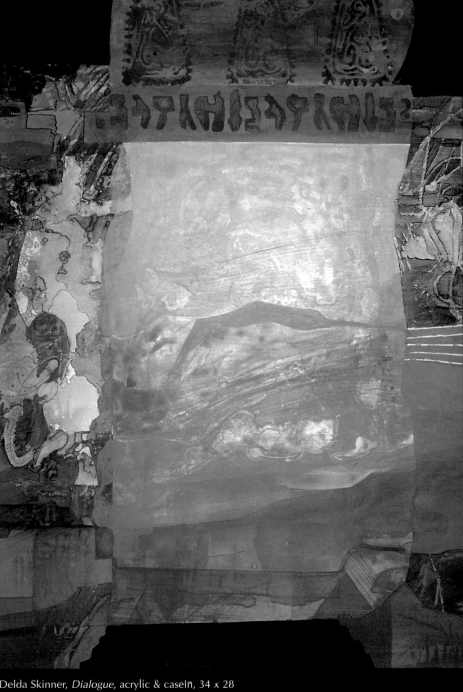

Delda Skinner, *Dialogue*, acrylic & casein, 34 x 28

EARTH
METAPHORS

BY MARY TODD BEAM

*A*ncient Greeks used metaphors to enhance an implied comparison that goes beyond ordinary understanding. Artists in this chapter extract from their immediate environment metaphors that become the vocabulary of their paintings. In so doing, they discover innate spiritual qualities in everyday scenes that allow them to transform their work into a deeper vision of our place in the universe.

The artist who follows this path enlightens the viewer through symbols. From ancient texts, we find water has long been a symbol of purification. In a fountain or river, water takes on more power and meaning. We speak of "a river of life" or a "fountain of youth." Streams and rivers have been compared to the veins in our bodies, symbolizing the flow of the life force throughout the earth. The environment becomes a metaphor for happenings

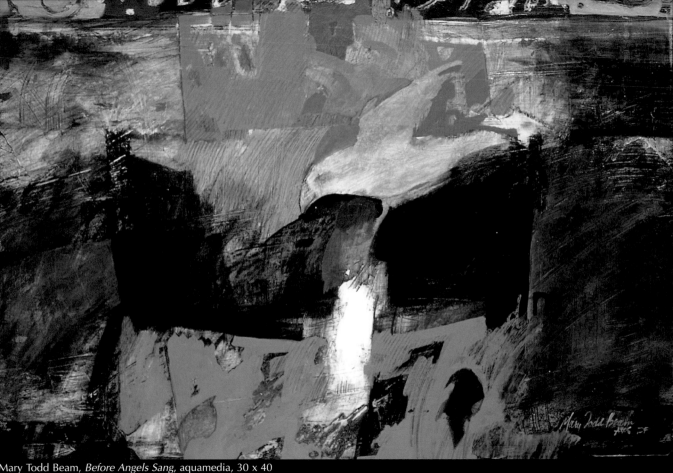

Mary Todd Beam, *Before Angels Sang,* aquamedia, 30 x 40

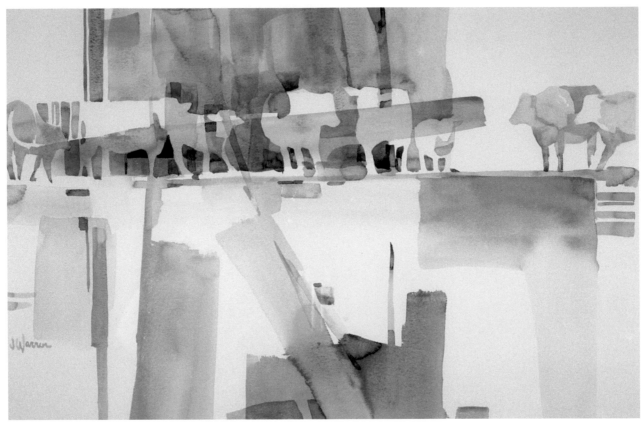

Jean Warren, *Hillside Images*, watercolor/paper, 22 x 30

in the artist's life. The presence of rain sets a somber mood; darkness can suggest death. Natural symbols add meaning and content to the work.

In this chapter, we look at our world through the eyes of artists. Our perspective is at first panoramic, with a distant horizon. Gradually, we will move to closer viewpoints.

I live and work in both Cosby, Tennessee and Cambridge, Ohio. My painting *Before Angels Sang* deals with one of the profound mysteries of life, the subject of creation itself. Why, when and how did this world begin? I explored this exciting question and gave my imagination free rein in my search for understanding these events. I find the acts of painting and

creation are connected. When I look into chaos in a work, I attempt to bring about some degree of order. This primal stage of creation is where the drama exists for me. My painting suggests that creation was a time of turbulence, but the process was always under control. Words were there in archaic form. The elements were beginning to brew. Color and texture symbolize this evolving theme. The bird represents the creative force directing the activity.

Jean C. Warren, of Los Gatos, California, chooses a view of the landscape in *Hillside Images* that, in lesser hands, could have been trite, but she sees it with new eyes. She transforms common animals into positive and negative shapes and

Patricia Harrington, *Sienna Woods*, acrylic/paper, 28 x 36

simplified forms. She suggests shadows and sunlight through large wash areas. The white of the paper symbolizes purity or spirituality. The cow is her symbol for humility. The horizon is her stage and the actors are in full view. Warren deftly paints a memory. "I like the 'artist's hand' to come through in the first washes of paint so the viewer can see my first intentions, the ideas, the creative process. In this early stage I feel the rhythms of being there, the sense of place and time, and the essence of movement. I superimpose images on the landscape and enhance them by painting around the forms," Warren explains.

Since ancient times, people have used the tree as symbol. It immediately suggests strength, shelter and nourishment as well as the life, death, rebirth cycle. Myth even suggests that trees symbolize the muse and may be referred to as she. In **Patricia Harrington**'s *Sienna Woods*, the trees are a symbolic family sheltering and protecting each other. This Lynchburg, Virginia, artist has developed her image with a limited palette. She has made exceptional use of shapes. Do trees talk? These do. They tell us their duty is to connect with man by providing us visual enjoyment and utility.

Harrington comments, "I respond to distance in landscape, beginning with the nearest layer, then moving on back through layering and interweaving the strata of the landscape. I stand in awe of trees, their random overlapping of color, line and texture.

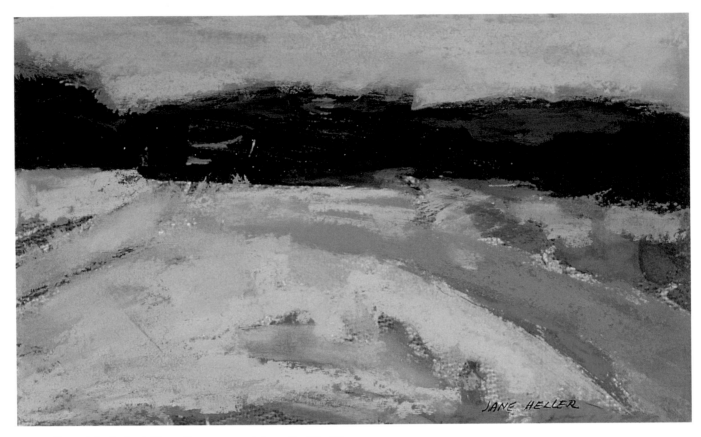

Jane Heller, *While the Earth Slept*, silkscreen, pastel & acrylic, 20 x 26

Granville, Ohio, painter **Jane Heller** says, "I am connected to nature! We share atoms, the stars and I, and we revere the other atoms that cling together to form trees, mountains, seas and all the other beautiful things in our universe. The anatomy of the whole is truly beyond my comprehension, but I intuit a relationship that makes me an integral part of the process. My painting *While the Earth Slept* symbolizes the earth at rest. The autumnal colors speak of quietude, the end of a season of growth, but a promise of peace and refurbishment. The land in fall directs us to restore our souls. We should listen."

To me, Heller's painting suggests that we are at a moment in the creation of the earth before man arrived. The earth is resting before another cataclysmic event. Heller sets this elegant stage and masterfully directs us through the painting at an enjoyable pace. She pauses for us to enjoy its silence. Man is only needed here as a witness to beauty.

There was a time in creation when the earth was "void and without form." A mist may have covered all things. **Marlene Lenker** takes us into this phenomenon in her painting *Baltra*, a mystifying, intriguing landscape inspired by her visit to the Galapagos. The vertical format further dramatizes the layers of earth, mist, clouds and mountains. The mood is somber and

Marlene Lenker, *Baltra*, acrylic/canvas, 48 x 36

Norma L. Jones, *Earth's Music*, mixed media, 36 x 24

pensive. Lenker enters this primordial scene by adeptly pulling information from the collective unconscious and her intuition.

The artist, who has studios in Cedar Grove, New Jersey, and in Connecticut, says, "I have been a landscape painter for over thirty years. My work concerns feelings of place. I never put objects or people in my work. I attempt to give the viewer a feeling that they have been there or would like to be there. Every day in every way I marvel at something in nature. I love it all and feel grateful to acknowledge the day."

Norma L. Jones, who lives in Albuquerque, New Mexico, leaves the traditional landscape for a view of an imaginary ocean in her collage *Earth's Music*. Through layering, she suggests the polarities associated with a large body of water. The ocean becomes a metaphor for the diversity of life, the good and the bad, the ebb and the flow of circumstances that surround us. Jones takes us on a leap of imagination into a place where the turbulence does not threaten. It soothes. She is the master of control. Order persists.

Jones says, "I feel more at home with nature than I do with people. My painting is not meant to be a certain place, but to have a mystical feeling more like poetry or music. I want my work to be more universal than one particular scene."

Jane Cook of Columbus, Ohio, is among a group of artists who are not satisfied with the usual landscape presentation. They yearn for a more intimate look. The facts are there and the viewer can feast upon their visual details, but, for Cook, design is of utmost importance. She leads the eye through minute changes in texture. Her painting *Metamorphosis* is a dramatic metaphor of timelessness.

Cook explains, "Each span of time has a way of contributing to the beauty we see and feel when we view changes in nature,

Betty Keisel, *The Wanderer*, acrylic/paper, 22 x 30

seasons and years. Since my visit to the ancient tumbled walls in the excavations of the tombs in Egypt, I have had a feeling for Time's structural beauty. I like to think that *Metamorphosis* is a memory of another lifetime, and I am recording a view of it. I have said, 'My art seems to come from unexplained sources and I find this most satisfying as an artist.'"

The Wanderer by **Betty Keisel** gives us a close-up look at her unique view of the earth. Rocks, misty water and bubbles floating leisurely past are metaphors for the fragility and shortness of life. The stream refers to the flow of events in history or in one's life. Keisel has masterfully manipulated or stopped this flow to give us a more contemplative view. As onlookers, we enjoy the mystery held by and under these rocks. Do creatures dwell there? Is this a make-believe world? Whatever it represents to us, we certainly enjoy its presence and focus.

Keisel recalls, "As I was driving home from Santa Fe to Albuquerque, I saw fleeting glances of the shapes and shadows on the Sandia Mountains. They were so incredibly dramatic that the images stayed in my head till I could get a brush in my hand. I titled this piece *The Wanderer* because it is free, yet solid like the earth, and it moves with the rhythm of time."

Priscilla Robinson lives and works in Austin, Texas and Taos, New Mexico. She is a known for distinctively textured handmade paper works that express her keen observations of nature. In her insightful painting *Where Rivers Begin*, she takes us to a lovely place, pristine and without chaos, where things originate. How unobtrusive we must be so as not to disturb this silent world.

Robinson says that her symbols involve the circle, the triangle and an unopened door. She remarks, "As time goes on, these shapes have simplified more and more. I have always found the triangle to be very dynamic. Its diagonals automatically set up exciting relationships inside and outside the shape's perimeter. Trees, valley and mountains are easily symbolized by the triangle. It was an inevitable progression for me to make these paper shapes and unite them." For me, Robinson's triangle symbolizes the trinity and the unopened door leads to the future.

As we move even closer in our view of the earth, we find that some artists see through the whole diversity of creation and come to re-create the very molecular or chemical structure of

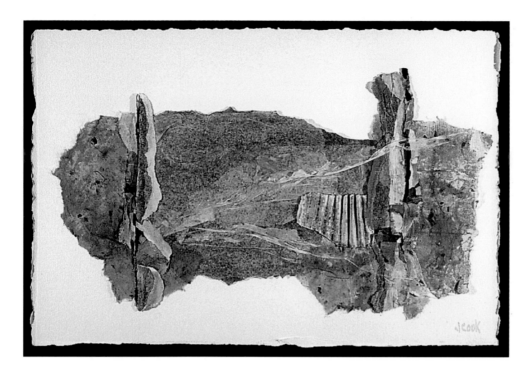

Left: Jane M. Cook, *Metamorphosis*,
watercolor & rice paper/corrugated paper,
14 x 22

Below: Priscilla Robinson,
Where Rivers Begin, acrylic & gold/handmade
paper/fiberglass, 17 x 43

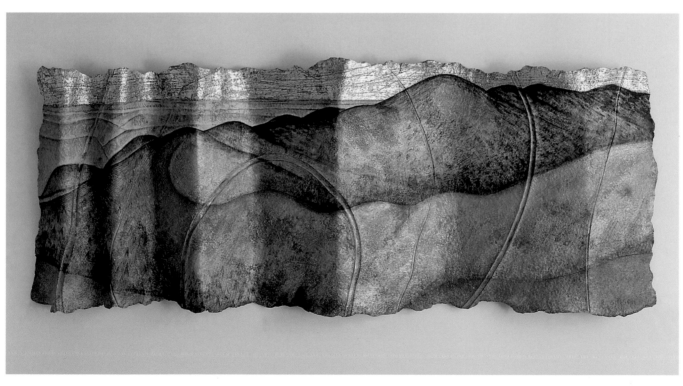

things. In her *Call to the Wind*, **Jenny Hunter Groat** deftly summons the forces of the wind to bring the chaotic fragments together. We enjoy the contrast of light rhythmically dancing through darkness. Hope is suggested metaphorically as the light becomes paramount. Groat's ardor for dance and music can be felt in the painting.

The Lagunitas, California, artist tells us, "My dominant theme has always been the vulnerability and beauty of inner and outer nature with or without humans. I prefer to think of my works as poetically evocative, since they are born from some place in myself that responds to nature by becoming identical with it. I want my artwork to be an expression of this nature-mind, something felt rather than described in words. I try to be dedicated to emptiness so that something beyond the personal ego comes through, and heart speaks to heart."

Dawn Wilde's *Thira Sea Moon* leads us further on our journey through creation, by presenting us with a three-part transformation of molecules and substances coming together to create one whole. Wilde symbolizes the void of the universe in the dramatic darkness. White is the sign of purity and perfection of her subject. She stages the drama in a wonderful sequence of images. All of these steps are necessary and vital in the creation process.

Wilde, who lives in Manitou Springs, Colorado, at the base of the Rockies, shares her process: "During my travels I take photos of parts of things, such as sections of a wall where there is evidence of the aging process. These fragments suggest to me the beauty of continuity and change. My work is influenced by richness of color, texture and form as well as the sense of connectedness that I know is everywhere."

Selene Marsteiner lives in a rural habitat near Cedar Springs, Michigan. She says, "For many years I have found myself drawn to the exaggerated winter shapes of the apple trees perched on hillsides against the deep-blue sky." With an unusual perspective, she leads us through a door in her shrine-like *Apple Tree* and we find ourselves in a special day full of wispy clouds, sun and barren fields with only one object, the tree, made clearly

Jenny Hunter Groat, *Call to the Wind*,
ink, watercolor, gold leaf & gouache/board, 40 x 30

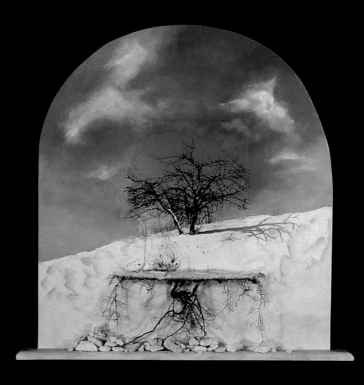

Left: Selene Marsteiner, *Apple Tree*,
photo, oil, roots, stones & moss, 31 x 31

Below: Dawn J. Wilde, *Thira Sea Moon*,
oil/canvas, 66 x 204

Doris Steider, *Entrances and Exits*, egg tempera, 20 x 16

dear and sacred by its loneliness. Here she presents us with a fascinating metaphorical world. We cannot escape from assimilating this hallowed time, ancient wisdom, simplicity and unspoiled charm. The single tree is symbolic of agelessness, strength and spiritual endurance. Marsteiner says, "After finishing this piece, I felt I had honored this solitary tree."

Most parts of a house contain metaphorical meanings. Of much significance is the door. It may symbolize for the artist a new paradigm or epiphany that has happened or the artist wants to happen. As in the classic story, "The Lady or the Tiger," we question what is behind the door. **Doris Steider** provokes the mystery in a very special way in her egg tempera *Entrances and Exits* with its magnificent pillars and detailed doorway that attracts the inquisitive eye.

Steider paints in her home in the Manzano foothills above Albuquerque, New Mexico, and alternately at her vacation home in northern Montana. A contemplative artist, she says, "Contrasts are principal teaching tools in our lives. Except through contrast, how do we discover that which we truly need? Entrances and exits are the extreme contrast; one is the coming in (beginning), the other is the going out (ending) … life and death. An exit from one place is also an entrance to another place, so we return again to the oneness …."

Altar of the Son by **Joanne Peltz** of Rockford, Michigan, brings our chapter to a conclusion. Peltz executed her close-up, spiritually charged painting while she was an artist-in-residence at the Franciscan's Life Center, where she taught handicapped and emotionally disturbed people. She places metaphorical shapes and figures in a classic setting, painted with low-key colors that convey a somber mood. As she explains, her deeply felt painting "transpired through a spiritual reflection of a previous work, the *Altar of Life*. I am referring here to the passages we go through that arise from the spirit and life forces while gaining new energies from the sun. The circular shapes represent for me holistic healing and insights, the communion with creation and my spirit."

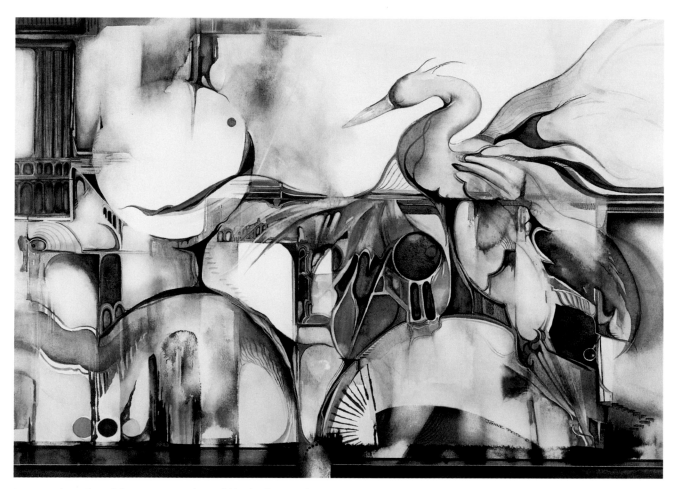

Joanne Peltz, *Altar of the Son*, watercolor, gold leaf, ink & acrylic, 22 x 30

COSMIC FORCES

BY PAULINE EATON

*W*hen we are young and we first learn that our *terra firma* is actually spinning through space, a flood of questions begins that eventually leads us into the cosmos. The sun also spins? Our galaxy is rotating? All space is expanding? Ultimately, we ask what our place in all that dancing matter and energy might be. And what causes all that rich Beingness?

Questing and searching for these answers, artists contribute their creative responses to the stream of human consciousness. In addition to empirical, sensate research, the artist-poet-singer-dancer-seer habitually brings intuition, meditation, creativity and insight to bear in their explorations. From this inner world, they return with revelatory forms, juxtaposed ideas, layered meanings, newly combined planes and inspirational visions.

The artist along with the scientist acts as a focused observer of the universe but adds, through introspection and experimentation, layers of time, space and spirituality not within the scope of the scientific method.

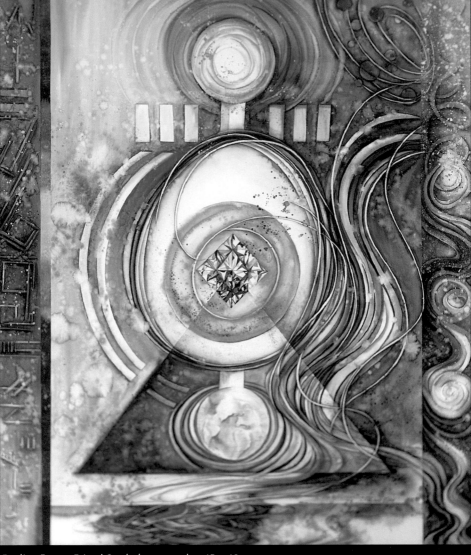

Pauline Eaton, *Primal Symbols*, watercolor, 45 x 40

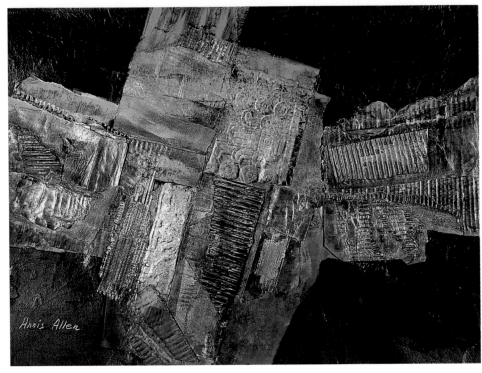

Annis Allen, *Other Voices, Other Rooms,* acrylic collage, 22 x 30

Layerists are especially involved in the huge stew of particles that together forms the Great Wholeness of All Being. As Teilhard de Chardin came to realize, our purpose is to be Creation conscious of itself. The Layerist willingly assumes the role of the mirror that reflects on the nobility and sanctity of life.

I live in Corrales, New Mexico. My painting *Primal Symbols* sums up many levels of my own spiritual explorations. With universal symbols, I seek to reveal the beauty of the complex mystery of All Being. The more male-like glyphs on the left are linear, measured, formal, angled and calculated. For balance, the circular spirals on the right relate to the feminine, which tends to envelop, aspire and ascend.

The larger design, based on a crop circle, refers to Gaia, surrounded by interstellar energy, defined by modern mathematicians as Super Strings. These threads of cosmic energy appeared spontaneously in my work twenty years ago. Gaia exists within the temple-pyramid of human spiritual aspiration.

My symbols transcend sectarian beliefs. I, too, use the bar code as a key to our identity within the cosmos, or perhaps the antennae that receive power from the Source of All-Intelligence and Light being broadcast from its symbol of swirling glory.

Annis Allen of Austin, Texas, begins her experimental creative process by gathering pieces of paper, corrugated cardboard, scraps of old magazines, glue and acrylic paints. She intuitively places and changes these elements, adding new layers as the piece dries, allowing the shapes and spaces to direct her.

In *Other Rooms, Other Voices,* she has created a temple-like arrangement of rooms and roofed wings that suggest a structure dedicated to religious or cosmic relationships. Within this textured temple are references to archaic petroglyphs. I am reminded of the Mayans' stone calendar of 26,000-year cycles, predicted to end at the winter solstice of 2012.

In room after room Allen leads us to unique chambers with separate meanings. Her colors gleam with spirit and sacred

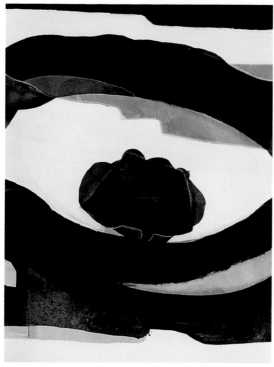

Nancy Franklin, *Central Focus*, acrylic/paper, 35 x 27

Brian L. Dunning, *The Awakening*, collage, 12 x 16

light. She surrounds the whole with the deep mystery within which we dwell.

Brian Dunning, a Denver, Colorado, artist, refers to the theme of time and rooms within the space of a dream sequence or memory flash. In *The Awakening*, he takes us into another dimension by showing space both inside and outside a win-dowed room. The sunbather in the desert looks into an interior where diving figures move in and out of consciousness—a microcosm within a larger context. The dolphin-mind rises from the dark, swirling pool of the unconscious to remind us of joy and to lift the swinging figure above the pool. A surrounding border brings to mind the game of life through symbolic suits of playing cards: hearts of healing, spades to dig, clubs to bloom as flowers, diamonds as jewels of experience. The commercial bar code refers to how we measure worth. Through introspection and empirical reasoning, Dunning explores simultaneous time of universes within universes.

When **Nancy Franklin**, of San Antonio, Texas, was deeply absorbed in the evolution of *Central Focus*, she felt very clearly that "someone was helping me." This direct guidance came from beyond herself.

Working on top of another painting, Franklin found inspiration in the texture below and in the new layer of color and form emerging under her brush. A basic spiral leads to the mysterious center devoid of light. Just as she used many colors to create this central focus, the black holes of space are created by the absorption of all matter and light.

By reflecting cosmic processes, Franklin affirms, "We are not alone. "Her painting is intended as a comparison. Just as we are the center of our own observations, on a cosmic scale, we are in the midst of galaxy formation, ultimate circles of mystery and black outer space rich in hidden complexity. Within the great circle of All, other intelligences, guides and beings share the space with us.

As part of a series, San Antonio artist **Linda Hammond** was "thinking about how the solstice affects us." The sun cycles back and "stands still," measuring time and recording the cycle of life. By working over older work, with its built-in textures and underlying forms, Hammond also serves the cycle of bringing in new life. She never believes a painting has failed, for the next layer of creativity will eventually bring it to fuller completion.

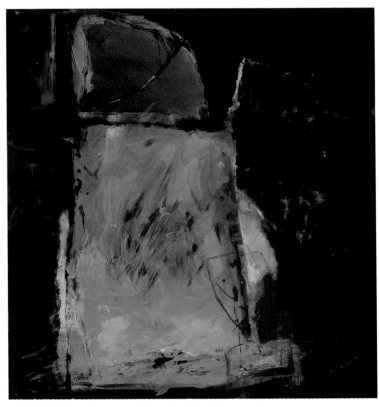

Linda Hammond, *Solstice*, acrylic & Caran d'ache/paper, 20 x 20

The glowing image of her *Solstice*, reveals a stone nicho within a temple of mystery—like Stonehenge, built to explain the movement in the heavens. By calculating the time of the solstice, the ancients allayed their fear that the full light would not return from winter's cold and dark. Linda Hammond paints the reassuring moment of full light magically illuminating the edges of her temple opening.

After seeing the petroglyphs of New Mexico for the first time, **Evelyn Lombardi Lail**, of Golden, Colorado, began a series on the environmental that grew from a previous cosmic series. Petroglyphs are her catalyst for thinking about marks, fossils, graffiti, textured sidewalks and wall surfaces. In *Runic Rhymes IV - Environs*, Lail seeks to ground the cosmic into our earthbound perspective. Through her open, flowing process, Lail builds layers of collage and color to make "land-like and water-like" forms within the monumental scope of sky, stone and ground.

Lail's painting suggests that hidden in the telluric realm are codes of unconscious knowing. The sacred space found in her painting encompasses the dark lake of the larger collective unconscious from which we explore the poetry written in runes by ancestors. Their creative, artistic and shamanic response to the impact of cosmic forces upon earth communicates over time our shared visions.

Tucson, Arizona, resident **Mary Langston** visited Tenabo, near Mountainair, New Mexico, and was inspired by the petroglyphs she "saw and felt in this ancient sacred place." Langston has placed Blue *Woman With Red Bird Creature* in a cosmic encounter drama.

Langston explains, "The eyes in the painting could represent those whose spirits inhabit the rocks and hills through the ages."

On a ground of handmade paper over canvas, the artist worked with acrylic and wax. After incising lines with a pencil pushed into the soft paper and gesso, she applied a red wash and the color was absorbed into the indentations. Black and red dots suggest an ancient form of measuring time, a calendar that orders cosmic forces. The artist as feminine shaman reminds us of how we identify with the quests of ancient humans who sought to lift the soul into the beyond.

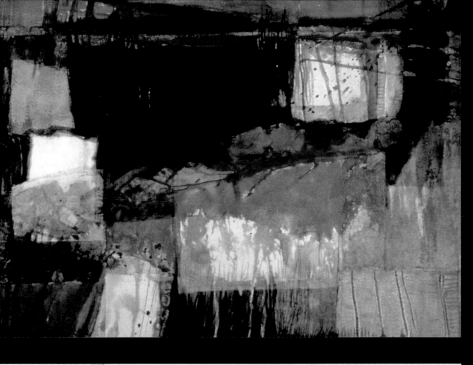

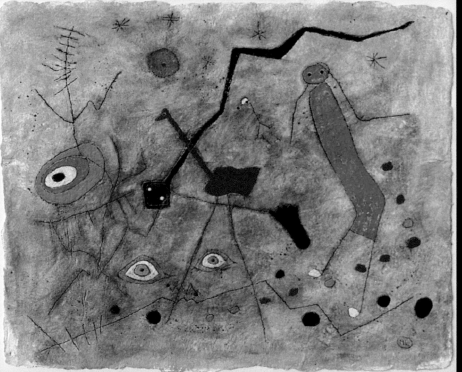

Above: Evelyn Lombardi Lail,
Runic Rhymes IV—Environs,
watercolor collage & gesso/paper,
 21 x 29

Left: Mary Langston,
Blue Woman With Red Bird Creature,
acrylic, wax, handmade paper/canvas
32 x 38

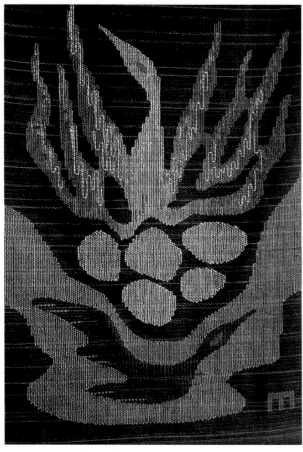

Marie Litterer, *Phoenix*, linen & cotton, 36 x 20

Ingrid Leeds, 1925-1997, *The Guardian*, acrylic & ink/canvas, 36 x 28

The Guardian by **Ingrid Leeds** reflects the joy of the artist's journey in the company of Layerists to England in the summer of 1997, to visit the ancient sites of cosmic worship found in Avebury, the Tor of Glastonbury and Stonehenge—all within the Wessex Triangle. Before her sudden death four months later, Leeds created this image of the last gateway of her life. The great stones and lintels of Stonehenge become the portal to the great circling light toward which she was headed.

On her final journey with us, Ingrid Leeds radiated joy in every aspect of discovery. She affirmed her own spiritual progress through a life that included fleeing from the Nazis and communists in Europe to Cuba and eventually to the United States. A fully mature artist, Ingrid Leeds lived in Bethesda, Maryland, and had a studio in Alexandria, Virginia, at the famed Torpedo Factory, which she helped establish. We have been blessed by knowing her and her glowing paintings.

Context means "to be woven together." In her weaving, *Phoenix*, **Marie Litterer**, of Camden, Maine, expresses our context in the cycle of living, dying and beginning life again. The rising, flame-bird conveys the human desire to fly, and in the cosmic context, to rise above our wounds, trials and death. We seek renewal and resurrection.

Janet Mikkelsen, *Emergence*, glazed & kiln-fired ceramic tile, 9 x 17

The dead bird below retains a glowing eye, a spark of hope—that deep need for a new chance. He reminds us of the creative process in which artists struggle each time they face an empty surface, waiting for the spark of inspiration.

The ashes, in turn, become the eggs of life, the source of new birthing. The phoenix-soul passes through the purifying fire, an energy that lives and ignites, and the combustion of the old elements releases the soul into new cosmic flight.

Context also means the environment in which we live and work. **Janet Mikkelsen** sees the Sandia Mountains from her home in Corrales, New Mexico. In *Emergence*, a dream-like image, the mountain splits open to reveal the spirits that reside within. Her work is a metaphor for the long history of humans seeking power in both high places and in secret recesses. Ritually, the animals and humans dance in the cavern darkness as family and community.

From the magical split a new life-figure emerges. Organic, but unlike existing forms, the figure represents the Creator. At its root springs the stream of life-giving waters that nourishes the dance simultaneously on earth and cosmic levels. For the artist, the piece was pivotal in her own emergence and she retains it in her private collection.

Lydia Ruyle, *The Center of the Universe is You!*, artist-dyed cotton pulp, 72 x 48

As a Layerist, **Mary Carroll Nelson**, of Albuquerque, New Mexico, celebrates the great revelations of both artistic and scientific exploration. The magnificent images now returning from the Hubble Telescope affirm her intuitive visions of the great pool of cosmic energy. Virtually giving "stalks to our eyes," the Hubble allows us to see beyond time into the majesty of space.

Over her painting *One - Heaven Ley Series*, Nelson illuminates plexiglas with sprays of cosmic dust, stars and spiraling paths of energy lines into space. Just as ley lines have been detected within the mantle of earth, so bands of energy leap through space. The soul figure is The Watcher. Nelson's eye-like nebula mirrors our sense of vastness and Oneness, and reminds us of the adage, "As above, so below."

Lydia Ruyle of Greeley, Colorado, brings her feminine message to *The Center of the Universe is You.* The quatrefoil echoes a crop formation that appeared in an English field, a form also found in Italian architecture as a frame for sacred stories. She built the work from many pieces of colored paper pulp, expressing the idea of numerous fragments making up the whole. The classic symbols of the circle and square balance, all lines meet in the center inhabited by the self, the witness, the artist. "You move," she says, "from the center to find out you ARE the center."

Ritual and spiritual travel have connected Ruyle to the shamanic energy of healing. She has led groups on pilgrimages and rituals around the world. She feels charged with a mission to expand awareness in herself and others of the sacred sites on earth that are connected to deep space.

T. F. Poduska's *The Source* is a squared mandala, a metaphor of the wovenness of All Being—our greatest context. Donning boots and wading into a large, specially constructed basin, the Littleton, Colorado, artist finds she lets go and is taken over by universal, spiritual guidance that carries her to the point of surrendering to the dynamic of painting, "where," she says, "I no longer exist." She cuts finished paintings into strips and weaves them into paper tapestries.

Mary Carroll Nelson, *One—Heavenly Ley Series*, ink & acrylic, plexiglas/masonite/gesso, 19 x 20

HEALING AS A JOURNEY OF DISCOVERY

BY CYNTHIA PLOSKI

A Native American reclines on a sandpainting, prepared upon consecrated earth by his Medicine Man, confident he will be restored to health. A woman with deep psychic injury intuitively splashes paint onto paper, discovering images in the patterns which will help her therapist shed light upon deep emotional wounds. A right-handed woman going through chemotherapy for breast cancer uses her left hand, bypassing the rational part of her brain, to draw pictures of her early family life. Rage and shame flow through her pen. Another woman works past the anger of a divorce, externalizing and healing her sorrow … emerging into new life.

Into the deep, rich earth of the human psyche, art's tendrils take root; spiraling down, linking earth and sky—mind, body and spirit—becoming channels of nourishment through which healing and transformation transpire. Imagery has been shown to produce biochemical and physiological change.

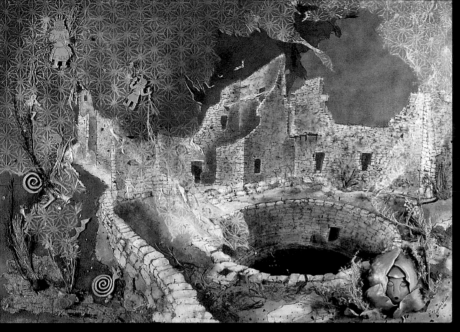

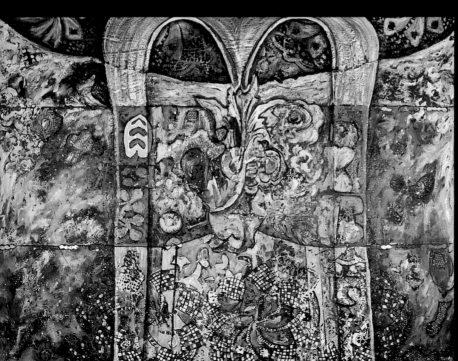

Above: Cynthia Ploski, *Creation Song,* watermedia, rice paper, clay & found objects, 30 x 41

Left: Linda Light, *Arch of Innocence,* acrylic collage/museum board, 32 x 50

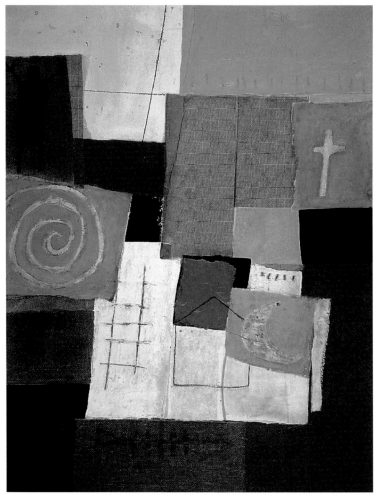

Mary Hunter, *Moon Spirit*, mixed media/paper, 30 x 23

I know this to be true. I was the woman with the left-hand drawings. When all the pent up emotions I had buried found life upon the paper, imbued with the energy of my distress, I was able to eliminate the hurts by ceremoniously tearing the drawings apart, burning them to ashes and stamping those ashes into the patient, receptive, healing earth near my home in Trinidad, Colorado. Only then did my body begin to mend. Only then could I resume the artwork that I gave to the outside world.

Creation Song tells the story of how Spirit brought all things into existence. The stage set is Spruce Tree House in Mesa Verde National Park. A terra-cotta mask of Spirit sings; Song is creative force. From a circular Kiva, a metaphor for Mother Earth's womb, song brings forth symbols, spirits, fragments of nature, borne on a starry veil of another dimension.

Linda Light's work was an important part of my own recovery. She herself had emerged from a life-threatening illness, which enabled her to offer support and encouragement in an especially meaningful way. One morning in the middle of my chemotherapy a wooden crate from Kansas arrived at my door. It contained a framed, full sheet acrylic painting by Linda Light of a healing crystal emitting multicolored light rays. She kept it by her bed until she was fully recovered and she was now sending it on to me. In place by my bed, I drew strength from the power of its images, and then passed its healing presence on to another breast cancer patient.

Light's art is a journal of her own physical and emotional path to wellness, which led her to Santa Fe. There, she teaches workshops in a beautiful adobe studio a few blocks from the Plaza.

"The painting *Arch of Innocence* is part of my *Arch of Triumph* series," she writes. "It was born out of a time of emotional recovery from a painful divorce after a long-term marriage. Immediately after the divorce, I was working on a series of paintings I called *The Healing Heart*, depicting a giant broken heart, and at the bottom was a tight band with a belt buckle slowly opening up. Then as I started to heal and came out of the dark tunnel of grief, my paintings took a dramatic turn. The heart opened up and became an arch, a winged figure, my guardian angel. This arch depicts triumph and victory, a spreading of my wings and flight into new realms ... the development of self, the bear coming out of hibernation."

For Oakmont, Pennsylvania, artist, **Elaine Morris**, assemblages such as *Goodbye Boston* are a vehicle "to deal with things that can't be dealt with any other way. Almost all my work concerns relationships with family—areas of crisis, loss, divorce, walking away from what the outside world considered a good marriage.

"I use sharp, painful and lovely feminine objects from my own family. The doll was made by my great aunt." The childlike

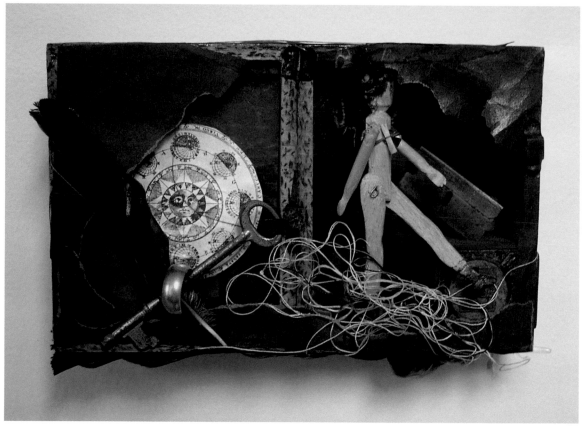

Elaine Wallace Morris, *Goodbye Boston*, assemblage, 5 x 8 x 3

doll, naked and unprotected, with mature breasts, steps confidently past a photograph of a male relative which has become a box with a sharp razor blade painfully lodged in its top. Entangling threads are being left behind; and yet, one foot still carries a tiny bit of that thread wrapped around the ankle. The face is thinly veiled as she moves out towards freedom and an uncertain life. Seeing it, I ponder my own life, my own divorce, new life and new marriage.

Mary Hunter writes, "The act of making art is in itself a healing process in that I am able to answer and examine my own problems and solve them through the work, consciously or subconsciously."

Hunter expresses her views with childlike images—simple blocks of color, boxes and figures anyone could draw. The child inside the observer can easily identify with such images. "If that art strikes a sympathetic or familiar chord in the viewer, then the person may also participate in the healing, or the emotional pleasure of joining me in my creative process," she comments.

Living in Rockport, Texas, she is familiar with Southwestern Native American symbols. In *Moon Spirit*, Hunter shows us a petroglyph figure, a sacred spiral, ladder and crescent moon, in blocks of color resembling Pueblo homes, and Christian symbols of a cross, a fish and a contemporary home. Viewers can decide if she is expressing belief systems, conflict, or harmony between cultures and perhaps be enabled to identify their own feelings of conflict or harmony.

Hanne-Lore Nepote, who lives in Millbrae, California, is the widow of Alexander Nepote. She is a versatile artist whose theme is harmony, especially as it pertains to the healing of Mother Earth and all her creatures. On the frame of her construction *We Do It To Ourselves* she has written, "We did not weave the web of Life. We are merely a strand in it. Whatever

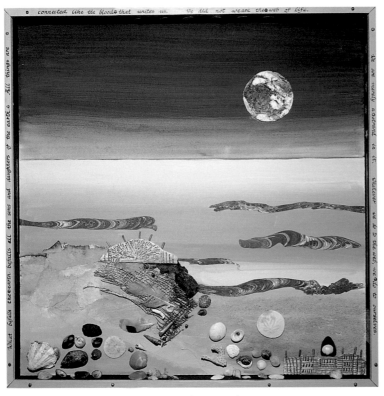

Hanne-Lore Nepote, *We Do It To Ourselves*, mixed, 24 x 24

we do to the web, we do to ourselves. What befalls the earth befalls all the sons and daughters of the earth. All things are connected like the blood that unites us."

We Do It To Ourselves is surreal. The images of sky and sea and shore are so familiar to us! They seem to say, "We are here, in familiar territory." Yet, the more I contemplate the scene she presents, the more I feel I have side-stepped into another dimension of our multidimensional world.

From the surreal it is only a little dance step over to the abstract. One leaves the world of objects as we know them, allowing our artist's self to move aside so messages from another level of consciousness can come through. Occasionally an artist creates a painting that just doesn't come together and in frustration puts it away to begin another. But these apparent failures may spur the creative process and be reworked into success.

Such a success is **Mary Stone**'s collage *Apparition*. As she describes the process from her home in College Station, Texas, "The image appeared gradually as I collaged an old painting with torn and cut pieces of a woodblock print I had done long ago. I did add paint as I went along, but with no idea of what was emerging from my unconscious.

"The painting underneath Apparition was a vertical with a lumpish gray-white underwater creature and an amorphous peachy-pink blob with no distinguishing features. Nonetheless, the image seemed ominous and menacing, so I just stashed it away. It is this change of energy from negative to positive (fragile and strange, but hopeful and airy) that I find healing.

"I read this image as genderless and other-worldly—a bringer of light. People seeing the piece respond favorably, so therefore it may come from a universal level, rather than only from the personal. The work reassures me, in a psychological sense, that I can trust the creative process."

The creative process can also be a vehicle for the healing balm of reconciliation. As an example, the umbilical chord between mother and child may be cut at birth, but survives in an emotional connection that never dies. Like a violin string upon which may be played many melodies, it can be plucked to create harmonics rippling through both mother and child.

Nancy Dunaway's mother passed away recently, after a long illness. Dunaway began working on *Dear Mama* for a home show. Home, to her, meant Mother. So the piece became the instrument through which she channeled a lifetime of resolving their differences into harmonies. It became a love letter to her mother, and she was able to give it to her mother six months before she died. Mama loved the painting. The healing was complete.

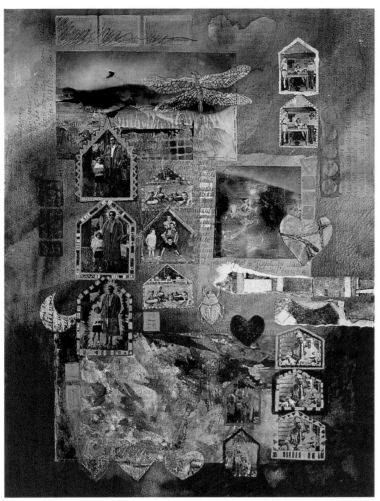

Nancy Lee Dunaway, *Dear Mama*, watercolor, gouache & prisma
pencil, 30 x 22

Mary Stone, *Apparition*, acrylic & pastel/paper collage, 30 x 22

Nita Leland, *Splendid Spirit*, watercolor collage, 15 x 20

"Relationships are many-layered," the artist told me in a phone conversation from her home in Hot Springs, Arkansas, where she serves as chairman of the art department at Southern Arkansas University. "This collage is a concrete manifestation of all the healing that had taken place over a lifetime. The energy of confirmation of my love for Mother is in this piece of artwork."

I am impressed with the lyrical quality of *Dear Mama*. It makes me want to send a valentine to my own mother. I see in the cursive writing, notes of appreciation. The photographs become little shrines of relationship, repeated in different shades of color. Another symbol, on a grander level, of flying free is the eagle.

Nita Leland also chooses the eagle as the primary subject of her collage *Splendid Spirit*. Leland is a well-known artist and teacher of workshops. She is the author of *Exploring Color and The Creative Artist*. Most recently she collaborated with Virginia Lee Williams, another member of SLMM, in writing *Creative Collage Techniques*.

Although Leland lives in Dayton, Ohio, she says, "Watching bald eagles soar in Colorado has inspired me to try to heal my earthbound Self through a quest for greater understanding of the spiritual universe. The eagle is a symbol of spirit, creativity and healing and has been the subject of many of my paintings. When soaring, the eagle is a messenger from the spirit world that

liberates creative energy and enlightenment. When attacking in the real world, this majestic bird represents the focus of creative energy. The balance of spirituality and conscious awareness opens the door to healing and wholeness." I also am awed by the soaring eagles I can see from my deck.

Bringing spirituality into conscious awareness was one of the main objectives of the 1997 Exhibition in Marlborough, England. **Jackie Schaefer** entered her pastel *Guardian Spirits*, from her ongoing series exploring women's roles in life and spirituality.

Schaefer painted three women as guardians. "Three just seemed to be the right number," she told me by phone from her home in Conifer, Colorado. "I've always been aware of Guides and Spirit Teachers. Some may be ancestors watching over us from birth, or some may come as a response to special needs.

"They are symbols of the feminine self. They carry circular golden plates that bear flames. The flame represents light. Healing is light. Light is energy. I try to pique the curiosity of observers, to get them involved. For example, did you notice that the flames are the same shape as the wings behind the spirits? Are they angels? What is the significance of the stars they carry? Getting interaction going between artwork and viewer allows art's healing content to flow forth and be received. Other people say my work has helped them and that is encouraging to me."

Interaction between artist and observer through artwork can stimulate restoration of harmony between body, mind and spirit. I was immediately drawn to **Stephanie Nadolski**'s *Passages XXIII*. I felt the water roiling and cascading over strong, sharp rocks. The image whisked me away to memories of tumbling mountain streams, caught in a moment of stillness on a mysterious journey. I wondered if I am at that still point of my life passage.

Nadolski, of Barrington, Illinois, writes of her work: "Recent pieces tend to capture the soul of an object, preserving it in time, saving it to share with others. In nature I search for a personal inner space that can best be explored in comparative

Jackie Schaeffer, *Guardian Spirits*, pastel, 31 x 23

Stephanie L. Nadolski, *Passages XXIII*, ink, acrylic, watercolor, colored pencil, monotype, 36 x 30

isolation and silence. I work intuitively, painting with a watchful eye, letting the work lead me, developing a soul and spirit of its own. I return to the spirits of earth and nature for my source of healing, renewal of body, mind and spirit."

Jeanne Norsworthy, who lives in Bellville, Texas, also projects a holistic spirit in her *Shaman Summoning My Broken Spirit*. The painting depicts a female shaman standing atop a mountain on the artist's Mexican ranch, waving a shirt Norsworthy wore when she suffered a terrible accident. To aid in healing, the shaman practices "soul retrieval"; she calls back the little piece of soul that broke away during the accident. In real life, Norsworthy's broken bones knit together ahead of schedule. She says, "I cannot say whether or not painting specific works of deep suffering and fear have brought about healing, or if I must first reach a certain level of healing in order to face the issue honestly enough to paint it. This painting speaks of the value of ceremony, whether it be ancient or spontaneous. We are physical beings, and it seems important to me to let the body be involved in its fullest way. The well of our joy is dug by our pain."

That the body responds to mind and spirit cannot be denied, whether the emotions carried in the psyche are of the dark or of the light. Angels are usually represented as light-bringers, symbols of God's care and protection. We tend to ignore the opposite polarity, personified by the fallen angels, angels of darkness. All life exists in polarity.

Well-being and depression were the opposites **Janet Mustin** found she had to address. From her home in Lansdowne, Pennsylvania, she describes her collagraph: "The image *Angel Pushing Away Darkness* came to me as I recovered from a struggle with depression. She is really two angels. One is split in two, facing downwards and surrounded by darkness, The other is unified, standing upright and surrounded by light."

It is easy to imagine the artist recalling the stages of her recovery as she lays layer upon layer of color over the angel of darkness, moving upwards to create the angel of light. This is a

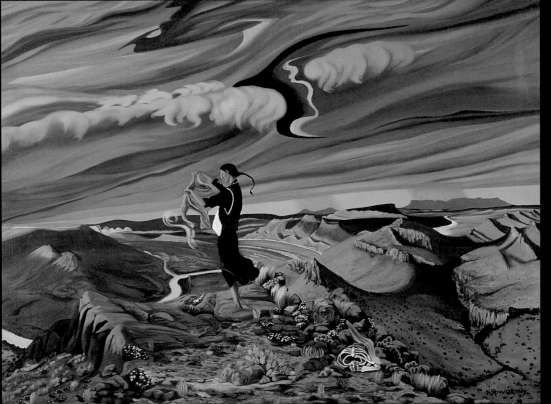

Above: Janet Mustin,
Angel Pushing Away Darkness,
collagraph, 15 x 28

Below Jeanne Norsworthy,
Shaman Summoning My Broken Spirit
oil, 36 x 4

Hilda Appel Volkin, *Radiance*, silkscreen on lexan, 96 x 12

triumphal artwork whose purity of form and line transfigure illness. Soaring above pain, the angel of light not only pushes away darkness, but stretches out her wings to proclaim a reign of peace.

Peacefulness and inspiration are the effects created by light-bearing panels of **Hilda Appel Volkin**'s artwork. Sitting before an altarpiece of hers in the quiet of an Albuquerque hospital chapel I was moved into a state of profound meditation. Volkin has created a number of commissioned installations for sites where people seek spiritual inspiration, comfort and hope.

"*Radiance*," Volkin says, "was designed for a meditation space to help create an uplifting environment of healing and inner peace. The radiance of the rising sun gives the power of life and energy. This vital spark purifies our senses, our hearts and our minds. Each of us has spiritual gifts, one of which is to heal. Through visual stimulation of art in a meditative retreat, one can find wholeness and spiritual guidance.

"Kandinsky wrote that color is a power which directly influences the soul," she continued. "Color is the keyboard, the eyes are the hammers, the soul is the piano with many strings. The artist is the hand which plays, touching one key to another, to cause vibrations to the soul."

The polar opposite of meditative peacefulness was **Ruth Meredith**'s experience within the structure of the doctoral program at the University of New Mexico in Albuquerque. During a very difficult graduate school semester, she made the book *Poetic Fragments #7*. On its pages she placed images of herself and two quotations from Pablo Neruda's *The Book of Questions*: "Is it true that they scatter transparent letters across the sky?" and "Why does the Professor teach the geography of death?"

Meredith explains, "These questions reflect my struggle to make sense of the direction my studies should take. I shape my life by making art. I bind a part of myself into the work. I felt the need to be true to my soul as well as my mind, and this is often very difficult to do in Academia."

Ruth Meredith, *Poetic Fragments #7* (page from a book), acrylic/paper, 12 x 10

Meredith became an agent of change. She is now following an experimental multidisciplinary degree in which she can integrate her interests in art, philosophy, religious studies, English critical theory, and the relationship between creativity and spirituality.

In whatever manner art becomes a channel for healing, the possibility of transformation is always present. To be made whole, restored to health, reconciled or brought into harmony, positive metamorphosis must occur.

In the fertile substrata of the human soul, nourished by thoughts and images, the healing journey of discovery can indeed take place, reflecting into interrelated body, mind and spirit. Art, from the heart and through the hands of an artist, forges a channel between internal and external world, opening possibilities for movement towards richer, healthier and more satisfying living. Art's own journey has brought it from an act of prehistoric magic to what may now be its greatest mission of all-healer of humanity.

ARCHAIC TRACES, EXPLORING TIME

BY BARBARA SEIDEL

Culture and civilization are but a thin veneer over the deeper evolutionary flow of time. Through the technique of layering myth, history archaeology—archaic traces come alive in the hands of SLMM artists who are exploring and reinterpreting ancient wisdom with relevance for today's postmodern culture. These artists, like archaeologists, peel back strata, revealing layers and artifacts from beneath the surface. The work in this chapter is a patchwork of styles, unified by the theme: ancient traces. The artists reveal intimate psychic processes, memory and forgetting, past and present, progress and interruption. Nothing is fixed or eternal. They are intermediaries for resanctifying life while opening to creative moments, places and materials that create temenos where others can share their experiences.

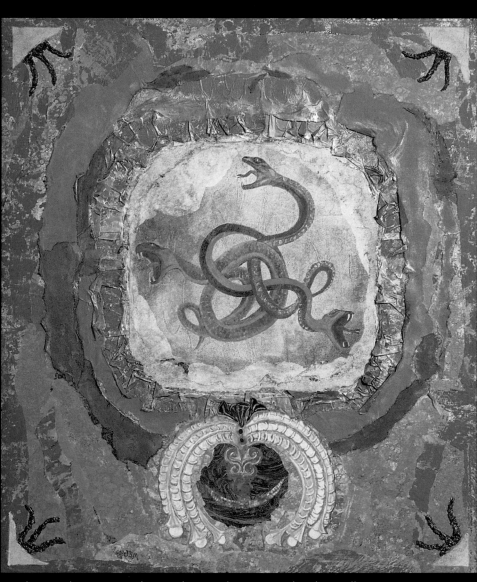

Marlene Zander Gutierrez, *The Guardians*, acrylic, paper mache, chine-colle
monotype/serigraph, 28 x 24

Nancy & Allen Young, *Yalu*, mixed media, 32 x 17 x 1

that her power animal is the anaconda, largest of all snakes. Her artwork apparently preceded deeper in-sights, buried within her psyche. Although Gutierrez may have been influenced by the symbol-saturated environment of New Mexico, where she lives, we can all look back on our choice of symbols as anticipatory of emerging awareness.

Kathleen Kuchar, who lives in Hays, Kansas, denies any archaic connection between her *Spirit Cat* and the world of spirit. She claims this image is simply her personal cat. However, historically, animals have provided humans with a strong link to spirit; in particular, cats are known as being the most powerful psychic familiars in the animal kingdom. According to shamanic traditions, we each have a power animal to guide us through life.

In addition to symbolism, there are many other ancient resources that can be accessed by a visual artist: a) shapes and forms, b) the collective unconscious, c) earth-based materials, and d) creative techniques that allow subject matter to emerge from process.

Layerists who adapt ancient shapes and forms include Albuquerque sculptors **Nancy and Allen Young**, who collaborate, combining elements from primitive cultures into uniquely composited new structures. *Yalu* integrates their recently cast bronze headdress with an actual Ashanti artifact, reconnecting threads from both contemporary and historical sources. *Yalu* suggests that we, too, are composites of everything that has gone before us. The Youngs achieve a harmony of their styles, his ruggedly carved standing "gods" and her soft palette that she applies to handmade paper sculpture.

As **Beverly Trumble** moved from New York City to the Colorado Rockies and then to Taos, New Mexico, she has come closer and closer to the subject of time. She has painted many oils of canyon walls and their mysterious sign language. In *Painted Canyon #5*, she layers current impressions over archaic marks made by the long-vanished petroglyph artists who preceded us in time and space. Trumble painted this series after a trip to Sego Canyon, Utah. Her paintings connect us with a feeling of place/space and the spirit of the people who once inhabited it.

As I probe the common threads of the fourteen artists in this chapter, I find most use symbols from the past to blend and connect with the present. **Marlene Zander Gutierrez**, of Albuquerque, New Mexico, focuses on feminine cross-cultural symbols, especially snakes. Serpents are the centerpiece for her mixed-media serigraph titled *The Guardians*. The importance of an artist selecting a particular archetypal symbol cannot be underestimated. Several years after completing this piece, Gutierrez worked with a shaman in a soul retrieval, discovering

Above: Kathleen Kuchar, *Spirit Cat*,
acrylic & watercolor/paper, 22 x 30

Left: Beverly Trumble, *Painted Canyon #5*,
oil/canvas, 36 x 48

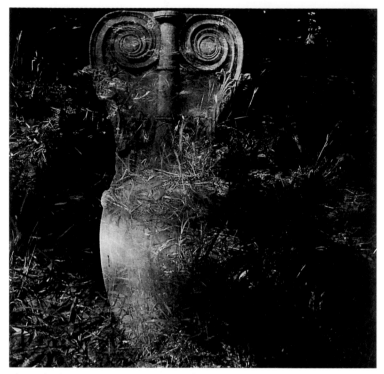

Elena Sheehan, *Antiquities Transformed*, multiple exposure selenium toned silver print, 14 x 14.

Barbara Wilk, *Witnesses*, bronze, 20 x 18.

Elena Sheehan now lives in Sonoma, California. A photographer, she uses a camera to superimpose images from Greek or Roman ruins, one image placed directly over the next. Her process results in the destruction of traditional form and the emergence of a new, more fluid reality. *Antiquities Transformed* is a multiple exposure, toned silver print showing a ruin in the context of its own metamorphosis. Time past and time present merge into one continuous organic movement. This image is about spirit and addresses the mystery, poetry and presence of the sacred in our midst.

I divide my time between Tiburon, California, and Aspen, Colorado. In both areas, I am deeply involved in the artists' community. The collective unconscious is a subject I often probe. *Archaeology of the Mind*, is an exploration of the inner workings of the mind with possibilities for accessing energies beyond the visible. A peep hole into the top of a sculpted wood head to reveal the skeletal remains of a seabird, a symbol of regeneration since Neolithic times. I've attached to the base, a Tibetan turquoise and healing root to evoke timeless ancient wisdom traditions and allow shadow traces of the past to transform into a contemporary assemblage.

Barbara Wilk lives in Westport, Connecticut, and Santa Fe, New Mexico, where she is involved in giving assistance to Native Americans. As a sculptor and teacher of ancient art, she reflects on her artwork, stating, "I am leaving my mark. Markmaking is a way of communicating with the spirit of our ancestors as well as future generations." She positions herself between past and present, acting as a witness to and interpreter of the collective mind. Her bronze sculpture, *Witnesses*, breathes new life into ancient tribal memories.

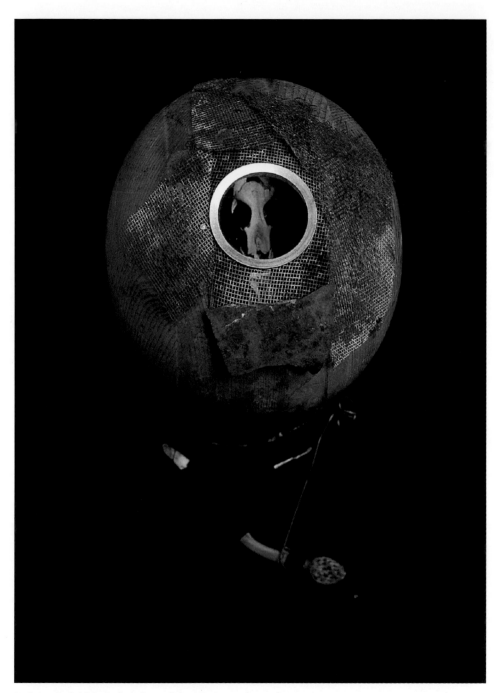

Barbara G. Seidel, *Archaeology of the Mind*, wood, metal, 14 x 8 x 1

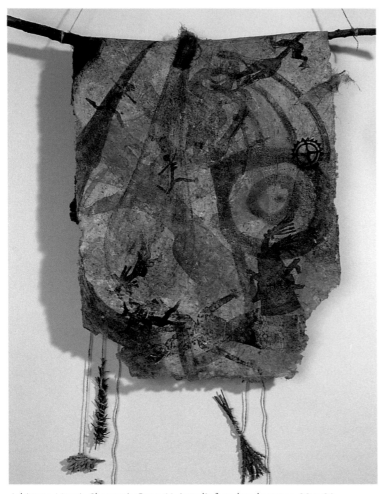

Adrienne Momi, *Shaman's Cape 11*, intaglio/handmade paper, 32 x 21

Earth-based art incorporating organic materials or clay is the medium of choice for many Layerists. **Adrienne Momi**, whose wearable paper cape is handmade from native vegetation, captures the spirit of the land and its people—in this case, the Chumash Indians of California. *Shaman's Cape #11* is covered with protective symbols and organic materials. Momi responds to the sacred plants of the shaman, seeing herbs as the context in which healing knowledge emerged. Momi moved from Missouri to San Jose, California, where she has been pursuing a doctorate degree in comparative religion.

Ilena Grayson is another clay artist who lives in the village of Placitas, New Mexico, with an awesome view of the north face of the Sandia Mountains. She digs deep, finding inspiration underground in the beauty of prehistoric animals from cave paintings. She says, "The animal is a vehicle for contacting the spiritual." *EL Pinto* reflects this inspiration in its richly earth-toned glazes, but Grayson has created a contemporary work, with abstract elements formed of unexpected materials. The horse's mane is leather stretched on a wire frame. The tail is of wire, the clay shields bound to the horse's sides contain fetishes. Unlike an earthly horse, this one has horns made from nails. Her references are the Plains Indians, whose bloodline she distantly shares.

Shirley Nachtrieb continued to live in St. Louis while her husband Earl made a two-week business trip to Saudi Arabia. They spoke with each other on the phone and lie brought her exotic artifacts of the journey as well as sharing his discoveries of another culture She combined papers from Saudi with torn scraps of a failed painting done during his absence. The rose is her symbol for love The Arabic calligraphy refers to Earl's memories of Shirley while away. On free time, he shopped the market and told her of the luxurious fabrics he saw there, so there is brocade in the work. The pieces are collaged together as a reflection of true love that bridges time and space.

Marilyn Christenson, who lives in the foothills of the Sandia Mountains in Albuquerque is a clay artist. *Natural Gate* is her earth-based sculpture. A reviewer commented, "Earth and sky come together like dust-covered treasures, holding promises of beauty." The gate, to the artist, is more than an opening." She sees it is an entry that leads to connectedness and wonder. Here the entry is narrowly restricted, which emphasizes a private moment of discovery. Christenson embellishes the surface of her work with irregular crevices analogous to the pitting caused by erosion from rain and wind. These depressions and the circular skyhole containing a clear crystal are glazed in a numinous blue. Christenson creates archetectonic forms that remind us of ancient civilizations.

Left: Ilena Grayson, *El Pinto*,
leather, fetish & wire/clay, 10 x 1

Bottom left: Marilyn Christenson,
The Natural Gate, clay, 14 x 7 x

Bottom right: Shirley Nachtrieb,
Postcard Series #. 2, mixed medi
16 x 12

Virginia Lee Williams, *Shaman's Symbols*, acrylic, paper & gold, 18 x 14

from the creative process. Both artists seek breakthroughs in self-expression, setting up conditions for the moment of accident, designing processes that allow for a spontaneous, perhaps channeled, encounter with the unknown.

Virginia Lee Williams, of Trotwood, Ohio assembles then reassembles previously poured upon or painted papers. She then enters into a dialogue with her work, waiting for an image to assert itself within the varied textures and colors. In *Shaman's Symbols*, she discovered the beginning of a mask, which prompted her imagination Building upon the idea, she created a visual narrative of a shaman returning to his village to heal others of his tribe. A symbol of the spirit circle of love surrounds the shaman like an aura. Williams distinguishes two veins in her work. She seems to move into a shamanic frame of mind while creating the pieces she calls "layered." She also exhibits watermedia paintings she does not describe as layered.

Carole D. Barnes, of Boulder, Colorado, works in acrylic on paper by allowing her work to spontaneously evolve from initial washes of color as she builds her painting, layer by layer. She seems to access sacred teachings from many different cultures. *Of Ancient Altar*, she says, "It felt to me like a chalice or sacred vessel of some kind. I pushed and pulled until an image appeared. When 1 paint I know what I am skirting around, so when I get a fragment or a glimpse there is a visual recognition of the elusive goal I am seeking. The value, I find, is in the search." Barnes often includes the presence of language, alphabets and signs that allude to the sense of ancient wisdom. She has scratched into the surface of this painting, giving it the aged patina of a found artifact.

Dorothea Bluck lives on a farm in West Lafayette, Ohio. She is rediscovering her connection to nature, an ancient connection that was once seamless and unmediated by language. In her *An Image of Time* she incorporates a crushed geode in her handmade paper, suggesting that knowledge of both physical and metaphysical worlds permeate the actual material of an artwork, which may transmit wisdom. Bluck creates a subtle contrast between easily broken geologic artifacts from the vastness of time and paper, which appears fragile but can last for centuries.

Two Layerists use techniques that allow a subject to emerge

Our challenge is to remain aware of the multiple layers available to us and make this awareness accessible to others. Interconnections between life and art speak across time and space, setting up correspondences, transforming reality, altering our perception of past, present and future. Archaic tradition fused with contemporary vision creates an existential vision of an ancient before, an open after.

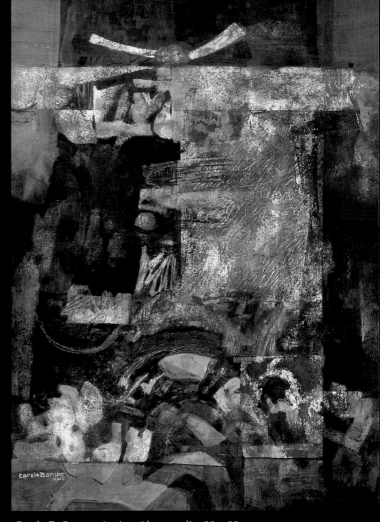

Dorothea M. Bluck, *An Image of Time*, acrylic & geode/handmade paper, 30 x 22

Carole D. Barnes, *Ancient Altar*, acrylic, 30 x 22

THE PULSING IMAGE ON THE EDGE OF THE MILLENNIUM

BY BONNY LHOTKA

*A*rtists have always used tools to express their ideas. As photographs and film influenced the first half of the twentieth century, television and the computer have influenced the way we interpret what we see and the way we work for the last two decades. Using the computer as an artmaking tool, we are now able to integrate information from a wide range of sources in ways previously impossible.

Some of the work in this section is created with software programs capable of allowing us to alter the size, shape and opacity of components and to seamlessly blend them into a coherent whole. The assimilation of images in a layered or fragmented manner is the foundation of the computer-executed image and a fundamental technique of computer programs used to create visual content. Other works in this chapter, even though they have not been executed with digital tools, show the influence of technology in their organization.

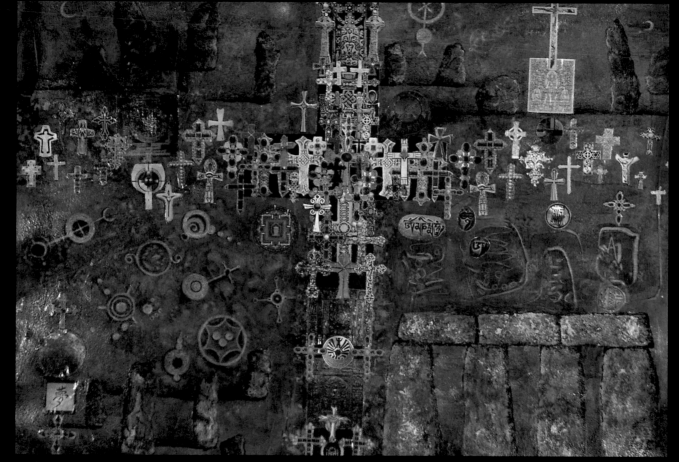

Marilyn G. Stocker, *England's Enigma*, mixed media collage, 20 x 30

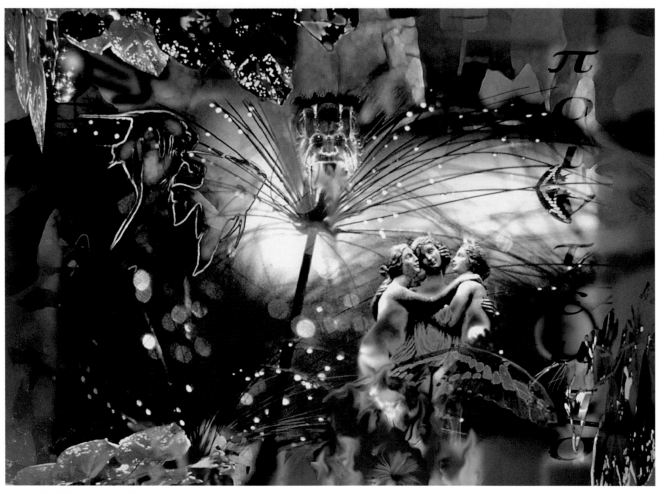

Lynne Kroll, *Le Printemps En Feu*, computer mixed media, 22 x 30

Never before has the artist had such a vast potential for social comment. We are able to combine in a single work a multitude of source images to bring meaning to our art. As artists we now have the means to comment on the future by reinventing the past; source images can be overlaid as abstract concepts and dreams of the mind. Layering of media can express movement in time through sequential images morphed on a screen.

Fear of the technological un-known can hamper our ability to work productively. It is a natural evolution of the artistic process for artists to adopt the computer as a tool of expression to make the art of the twenty-first century. The notion that the computer makes the art is as silly as the idea that a brush makes a painting. The eye and hand are guided by the mind and all great art must come from exploring the universe of our own soul. The canvas is glass, transparent, reflective and elusive. Much of the art of the future will be produced as pixels on a screen. We must reconsider the need for permanency of the physical object and be open to embracing and using the tools of the future as they become available to us.

Crosses from many cultures, with multiple meanings, some

predating Christianity by centuries, are combined with the center, the circle and the square to make a large cross in **Marilyn Stocker**'s *England's Enigma*. In shades of antique gold against a dark night sky, they advance and recede, some bright and dominant, others fading to obscurity. The stone circle, incorporating history, myth and legend as a site of worship, an astronomical marker and a link between life and death anchors the image both visually and allegorically.

Stocker believes we are not alone in the universe. The Newark, Ohio, artist says, "Crop circles, Stonehenge and the Avebury Stones left by unknown travelers have greatly influenced my work. I use a collage of crosses not to represent Christianity but to symbolize all religions. The Aquarian cross with equal arms embraces all of humanity. I paint from an emotional response to these symbols rather than from an intellectual one."

In *Le Printemps en Feu*, **Lynne Kroll**, of Coral Springs, Florida, uses a computer to seamlessly collage plant forms, a statue of the three graces, the neonlike outline of fish and other symbolic representations. A fire-breathing gargoyle brings light to the darkness, illuminating a glistening wonderland sparkling with dew. Both the fire that purifies and regenerates as it burns and consumes, and the spring with its promise of rebirth are symbols of hope and renewal.

Against a background of amorphous color cloudlike atmospheric forms and barely legible text, the delicate wings of an angel (or butterfly) have been affixed with a harness. Contrasted with the small dark, constricted image of ravens, traditionally performers of prophetic roles, guides, omens, messengers of the Gods, this haunting image by, **Juliet Wood,** of Ross, California does indeed give a promise of *Second Chances*. Alicia Miller, *Artweek*, has written of Wood's work that it is "unapologetically about art as a means of spiritual journeying. Her pieces are meant to depict 'inner journeys of evolving consciousness.' She draws on a range of mythic traditions...." Woods writes in her poem, *Blessing,* "May a slow wind work these words of love around you as an invisible cloak to mind your life."give a promise of *Second Chances*.

Juliet Wood, *Second Chances*, silk, print & paint 32 x 27

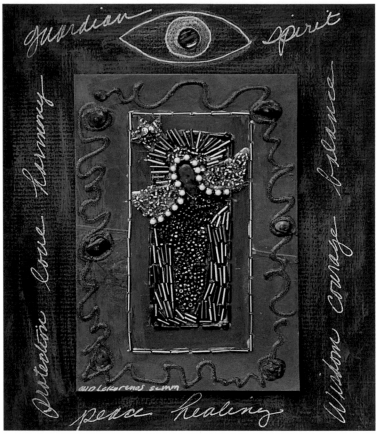

Marie Dolmas Lekorenos, *The Guardian Spirit*, acrylic, fabric, paint,
tones & beads/rice paper, 10 x 8

As an almost universal symbol the eye is not only the organ
of visual perception but the recipient of light by which the
intellect, the heart and the soul are made to understand. The
Guardian Spirit, by **Marie Dolmas Lekorenos**, is a mixed-media
piece that shows the richly beaded and jewel-encrusted spirit
surrounded by the words protection, love, harmony, peace,
healing, wisdom, courage and balance while the all-seeing eye
hovers above.

The Cambridge, Ohio, artist's name in Greek means emerald,
which is the source for the green stone in the central figure that
is a symbol for herself. The eye appearing above the Greek
Orthodox altar suggests a connection to nature with the use of
crystal and amethyst as collage elements. "The natural stone
connects us to the spiritual world and the universe," she says.
"The stones represent the healing power of the all-seeing eye of
a guardian spirit beyond that of any one religion."

In the yin and yang which is the center of **Diana Wong**'s
Quantum Bubble, the bright and dark forces of all things
heavenly and earthly, positive and negative, exist only in
relation to each other; inseparable, the rhythm of the world
is the rhythm of their alternation. The center, created with
the mathematical precision of sine curves, is surrounded by a
randomly cracking layer that is permeated by the void of space.

The Santa Monica, California artist pours transparent enamel
over glass to make a skin that floats above the deep pool of
mysterious color much like a nebula in space. An orb-like object
emerges from this pool of luminous mysterious color. A sense of
primordial evolution looms at us from the depths of color
and glazes.

"The multiple world of unending cycles with no beginning
and no end" reflects Wong's interest in science, evolution and
the universe. As she continues to explore symbols of different
cultures, we are invited to join the cosmos and look into our
soul and unconscious.

With its heavy black border, **Frances Dezzany**'s *Sandwiched
in Technology* captures natural objects behind a wire screen.
The landscape photograph surrounded by feathers and hand-
made paper is overlaid and patterned not only by the repetitive
grid of the wire but also by the shadow it casts.

"My work speaks to the encroachment on the diminishing
pristine wild by technology's use of natural resources for mass
human consumption. The wire grid suggests imprisonment and
protection of an idyllic nature. Some natural elements are
manufactured and processed items, recycled in this collage.
Nuts, bolts and metal tubing secure the grid frame to the piece."
'The cause of the decline, not surprisingly, is human,' clearly
punctuates the message of this Dallas, Texas, artist.

Above: Frances Dezzany,
Sandwiched in Technology, wire mesh
photos, paper & feathers, 10 x 12

Left: Diana Wong,
Quantum Bubble, acrylic/enamel,
36 x 36

The brilliant colors against the bright white of the snow in **Jeny Reynolds'** *From the Chair Lift* present an image which might as well have been seen from a satellite, an airplane or through a microscope. The shapes, at whatever distance, merge and flatten, tugging our perceptions and our memories. As philosophy and religions have long claimed and fractal geometry has recently demonstrated, the world is indeed in a grain of sand.

The Columbus, Ohio, artist says, "I started this painting in the West and finished it in Ohio. The seasons had also changed from winter to summer. It represents a passage in time in my own life. Aerial views overlaid with the geometry imposed by man on nature as seen from the air create a kaleidoscope of patterns I explore in my paintings."

Using fragments of images from the world of music and dance, **Valaida D'Alessio**, of Lockport, Illinois, creates a powerful composition of pulsating shapes in her *The Beat Goes On.* She uses a nearly monochromatic palette punctuated with exclamations of red, reminiscent of piano keys or sheets of music The superfluous has been obliterated by white; melody and harmony erased so that only the strong and powerful beat remains.

The influence of Larry Rivers is evident in the spontaneous execution and erasure with white paint of underlying collaged elements. Of this piece D'Alessio says, "I scanned family photos and enlarged them. The prints were reworked and integrated with playbills from musicals which are nearly obliterated by layers of acrylic paint then scraped away in places to reveal another moment in time."

The four three-dimensional pieces in **Marilyn Markowitz's** *Goddess Fetishes Four* incorporate archetypal goddess figures and symbols from a range of cultures and time including the Egyptian eye of Horus, the Cybele of ancient Crete, the yin and yang of Asia and the cowgirl of the American West. The undulating shapes of the figures that remind us of effigies are covered with a patina of rich gold and are enhanced with shells, feathers and bones. They occupy a place akin to a reliquary, fetish or icon. Markowitz's images derive from her travels around the world. The Boulder, Colorado, artist paints

Jeny Reynolds, *From the Chair Lift*, acrylic/canvas, 42 x 32

Above Valaida D'Alessio
And the Beat Goes On,
ink & collage, 30 x 40

Left: Marilyn Markowitz,
Goddess Fetishes Four,
mixed media, 6 x 18

spontaneously and assembles her collages from her unconscious, without preplanning. Her ability to create intuitively, she says, is "nothing more than instant recall of past experiences."

We may look back both by physically turning and by reflecting on the past; the woman in *Looking Back* by Massachusetts artist **Dorothy Krause** seems to do both. Merged with the names of places from an old globe, she is not bound by geography or time. Her strength is the ability to learn from the past and to look back without recrimination—without "turning into a pillar of salt." Thin veils of color build to a rich, luminous wrapping that envelops the figure. Cloaked in fragments, she haunts us and her despair leaves us wanting to know her story. She is at once surviving and decaying, living and dying, young and old. The intense gaze of her eye as she reflects on her own human condition gives us few clues. She could be someone of any culture. This is a soul-searching work.

A hive has no place in the life of the butterfly. It is a bee house and insofar as it represents a hard-working collective, the hive symbolizes an organized and directed confederation. In my image of *Hive*, the superimposed butterflies lead us to question the relationship between the two. Although, the butterfly is a thing of exquisite beauty, these dark, brooding creatures cling competitively to the top.

From my home in Boulder, Colorado, I have written about the piece: "There is an anger inherent in these beautiful things which have become ugly and threatening because of competition. The endless cycle of life and death is expressed in the use of the butterfly in the process of metamorphosis. Through my physically scrubbing out and repainting this image the entire process was an exercise in rebirth. Luminous pearl undercoatings express the spiritual light of the universe.

"Transparent and only a skeleton of black lines, the foreground insect appears as if waiting for a transformation of the spirit or resurrection. We are given the potential of hope for the future—at the edge of the millennium."

Dorothy Simpson Krause, *Looking Back*, digital collage, 52 x 38

Bonny Lhotka, *Hive*, mixed media inkjet/monotype, 50 x 40

THE
HOLISTIC SPIRIT
ASSOCIATE MEMBERS OF SLMM

BY MARY CARROLL NELSON

"Nothing exists in isolation."
— Sister Wendy Beckett

*O*ur vision expands as telescopes, microscopes and cameras extend our sight inwardly and outwardly, thinning the veils of distance and density. We have seen man walking on the moon. We recognize the rocky red surface of Mars, the rings of Saturn, the huge spot on Jupiter, the explosive death of a star. At the same time, our earthly connections are deepening. Magnified views of our own body parts are strikingly comparable to those of other creatures evolving alongside us. We witness miracles—a baby gestating in its mother's womb, the structure of cells, bacteria, crystals, metals—the depths of the sea.

Traveling by jet, we can cross the world in a single day and return with our visual memory banks overflowing. Events on remote continents reach our television screens, touching our emotions as if they were next door. What used to be foreign has become familiar.

Mary L. Crest, *Fluid Paper Letter Rivers*. plaster, suede & paper 7 x 5 x 5.

Elaine Insero, *Renewal II, Seed Pod*, collaged monoprints/paper, 30 x 22

Today, the forward impulse in human thinking is holistic. Artists who are more sensitive than most to currents of thought wafting ceaselessly from mind to mind appear to have had advance warning of a global change in consciousness. Layered art is a creative response to holism. Layerists are expressing their vision of a web connecting the whole of creation within a space/time continuum.

In 1982, after recognizing that layering is a meaningful way to make art, I approached Ellen Landis, curator of art, and James Moore, director of The Albuquerque Museum, with my proposal to curate an exhibition of layered art. They scheduled it for the summer of 1985. At first, I was certain it would be a snap to find a group of Layerists, but the project took the full three years.

I began curating the exhibition in May of 1982, just as the Society of Layerists in Multi-Media received word of its incorporation from the State of New Mexico. The evolution of the society and the exhibition were separate but related activities that expanded the network of layerists. Of the thirty-one artists in *Layering, An Art of Time and Space*, seventeen joined SLMM.

SLMM's non-taxable status rests on its educational purpose as a source for information about and exhibitions of layered art. From its inception, we established two categories of membership, full and associate. Associate membership is encouraged and is open to everyone. Becoming an associate of the society is a perfect solution for an artist or art-minded person who shares the ideas SLMM represents but may choose not to go through the process for full membership.

Associate members bring a vital increase of creative energy to SLMM. They participate in our gatherings and shows, especially local and theme-based exhibitions, and those "suitcase shows" that we take with us when we travel together.

It is a pleasure to present the work of associate members in this chapter. I will be searching for the distinctive voice of each selected artist. The reader will see how closely their images relate to the themes from earlier chapters. Taken together, they form an introduction to the holistic spirit.

Mary Crest's *Fluid Paper*, Letter *Rivers* is a superb example of multiple references in layered art. I immediately responded to the human connotation of the hand holding the curling, space-filling strips of paper on which Crest has written a poem. The artist, a resident of Pomona, California, began musing about the ways we express ourselves in many languages through vowels and consonants. She wondered what might happen if the paper dissolved, returned to its origin as pulp, was reconstituted and became another message entirely. Like a river, she says, "All of our words go on forever." She sees the work as a self-portrait. "This whole subject means so much to me. I've barely scratched the surface."

Renewal II, *Seedpod* by **Elaine Insero**, of Bradford, Massachusetts, is a monument to new life and a memorial to her father. "For a while, I was going to the cemetery every day," she says. "The death of my father was my first big close loss. At first, everything was dark." She uses yellow in this piece as a healing signal to herself. Insero formed the seedpod, resembling a womb, from pieces of her monoprints that she stitched to paper. She also built the sheltering structure for the pod of monoprinted elements. At first I thought it was made of wood because it so convincingly resembles the architectural niches in ancient European churches a reference intended by the artist.

Margaret Craft Miller, from Dublin, Ohio, also uses the word *Renewal* as the title for her poetic watercolor. Splashing foam screens the shore of what appears to me as a rushing white water river. Miller layers watercolor intuitively and then adds collaged portions torn from previous paintings to the surface, fully aware of the energy brought to the work from these earlier incarnations. "I paint from the inside out. While I'm painting something guides my hand. I let the painting tell me what to do." Although she did not consciously determine the subject of her piece, Miller understands its meaning. "Water is a renewal symbol. In Christian beliefs water washes away the past and makes you a new soul. Wherever water is used for purification it represents renewal of the spirit and the body."

Margaret Craft Miller, *Renewal*, mixed media/paper, 6 x 5

Nancy Egol Nikkal, *Silence,* collage, 26 x 22

Nancy Egol Nikkal lives somewhat reluctantly in Tenafly, New Jersey. She dreams of the western desert, but in her frequent visits to New York she enjoys its bounties for artists. In *Silence* she creates her own desert. With her currently favored colors of yellow and beige, she alludes to a standing African man, perhaps a shamanic figure. Nikkal says, "I'm intrigued by totems. My collage is organic, like a puzzle that represents layers of time. What I'm really thinking about is all the noise of the city, and the disconnect between words and meaning. I'm dealing with too much dialogue, but in my work, time is stopped. Noise is stopped." Nikkal believes that the peace we are seeking within is asleep and waiting to waken. "It's up to us to reach for it."

One of **Linda Penrod**'s favorite places is West Texas around Ft. Davis. She and her husband drive there from Austin taking their telescope with them to view stars in the amazingly clear atmosphere of the area. From the T-shaped window of a shelter built long ago by the CCC, she looked out on the wide desert and took a color photograph. On the under-painted ground of *Landscape Memory,* she placed a print of the image within a darkened window and gradually over-glazed the painting around it. The composition repeatedly echoes its T-shape in the same way a scene reverberates in our thoughts long after we have observed it. Penrod recalls, "The whole place is like a spiritual sanctuary, with a life-affirming feeling. It suggests a passage of time … like when you view stars, looking out at a vast distance."

When **Rowena M. Smith** traveled in Marrakech she had a frightening encounter on the city street with a practitioner of black magic. Suddenly he put a snake around her neck and would not take it off without payment. Smith had no money with her and found herself beseeching passersby for help. Some time later, she exorcised the horrific memory in a series of watermedia paintings, of which *Fakir et Cic* is the third. Each of them is based upon a cruciform—her favorite way to divide the surface. Without knowing the story, I reacted to the ominous mood of the work, its rich patterning, snake heads and the fakir himself. What struck me first was the contrasting flute, made of bone, like a streak of light in the dark. Smith says, "I painted it

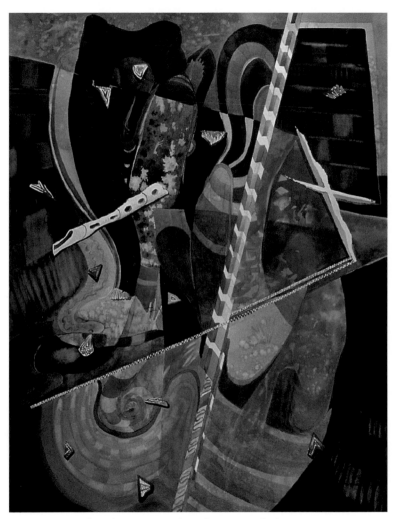

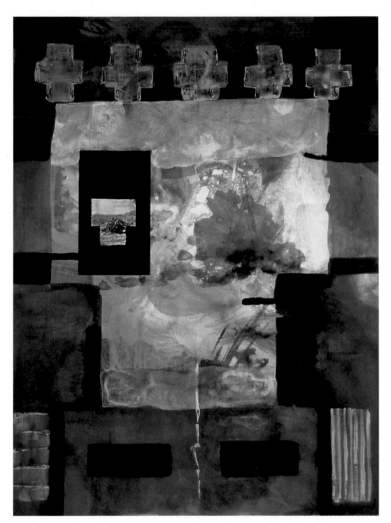

Rowena M. Smith, *Fakir et Cie*, acrylic, ink & watercolor/paper, 36 x 28

Linda Penrod, *Landscape Memory*, acrylic & photography collage/paper, 28 x 23

Cara Smith Stirn, *Brief Pursuit of Pleasure*, ink/Morilla, 29 x 21

the way I felt." She shares her credo with her art students in Tamarak, Florida: "Painting is from the soul. It should cause a chill down your spine."

Before starting her day in Cottonwood, Arizona, **Waneta Swank** was feeling great, drinking her first cup of coffee, when she realized, "It's a new day, filled with possibilities. I'll arrange it as I see best, putting things in perspective." These ideas inspired *Introspection*, an acrylic and tissue collage. The figure standing in silhouette is Swank, who is tall and thin. The delicately painted overlapping panes of light, defined with clarity and precise darks represent her state of mind when the morning is fresh, fertile and still to be accomplished. "Everything is ahead of me. There's a sense of order that I want to bring to my art."

Cara Smith Stirn comes from three generations of butterfly collectors. Her painting *Brief Pursuit of Pleasure* is a tribute to her many associations with these fragile creatures. "I love butterflies. I got interested in their colors and it led me to painting. They went together. Butterflies say 'freedom' to me. They can fly anywhere, go anywhere. They only live a short time, but they aren't conscious of death. They have a wonderful life, filled with flowers and everything beautiful." Stirn places strips of plastic over a moist, abstract underpainting and lets it dry. This piece began as a geometric grid, left idle for some time before Stirn had the urge to overlay the flat pattern of variously sized butterflies. I was caught by their transparent wings, which seem to make circular windows allowing a viewer to see smaller wings below. I asked about the relationship of transparency and overlapping with time. She said, "I always put circles in my work to introduce time." In this piece she contrasts the permanence of earth time with the impermanence of butterflies. Stirn and her husband run a dude ranch in Jackson, Wyoming, during the summer. She tells me, "I dream up what I'm going to paint while horseback riding. When I look down from the horse, I see flat patterns."

Caroline Garrett, a teacher, therapist and book illustrator living in Sante Fe, New Mexico, works with colored pencils to draw intuitive mandalas filled with representational archetypal symbols. The horse in *Don White's Power Mandala* is Pegasus,

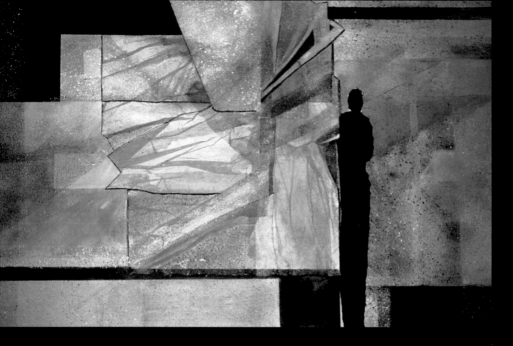

Above: Waneta Swank, *Introspection*
acrylic & tissue paper collage/paper,
24 x 32

Left: Caroline S. Garrett,
Don White's Power Mandala,
colored pencil/canson, 22 x 30

symbol of Sagittarius. Pegasus achieves his sky nature without losing contact with Gaia, the Earth goddess. The theme is transcendent. The female energy of the moon and Earth goddess balances the male energy of the horse. "The mandala is like a life story," Garrett says. She writes, "Come with me into my mandalas to another layer, another dimension Mandalas are created out of vibrations ... vibrations emanating from sound into light into pattern and finally into form The pictorial elements of personal power mandalas travel from one dimension to another, gathering up relevances, creating relationships between inner and outer, ancient and future realities."

Garrett's perception of mandalas could apply equally to layered art. I sense this kinship among artists who want their art to carry philosophical content. Their techniques vary, but their intentions are close in spirit.

Helen R. Meines uses oil pastels for her series of symbolic mandalas. *The New Fire* expresses her interest in connections between tangible and intangible aspects of human consciousness. It makes me think of the wheel of life in sacred Indian art, an idea confirmed by her statement: "From my recent involvement with T'ai Chi as an internal martial art, I have become much more aware of the energy within the body and its relationship to the mind and the spirit and have begun to find ways to portray this."

The Cincinnati, Ohio, artist relies upon her subconscious mind in making choices of color, shape and line, with each subsequent choice growing naturally from the first. As this work developed, the symmetrical image became a central sun and the dynamic fire emergent from it an analogy for the mind afire with new wisdom. Meines believes the sun to be a source not only of light and energy but also of transformation.

Dolores Ann Ziegler-Schilling lives in Whiting, New Jersey. Her acrylic collage, *Holiday Windows*, carries the wonder of discovering a window alight with festive decorations. Conversely, it also suggests those pitiful characters in children's stories like *The Little Match Girl*. From the cold outside, we look

Helen R. Meines, *The New Fire,* oil pastel/paper, 14 dia

into unreachable warmth and comfort. Ziegler-Schilling creates magical contrasts in value, texture and emotion, concentrating the areas of potent life-giving pleasure amidst the darkness.

Holiday Windows is part of an ongoing series that may be Ziegler-Schilling's search for answers to the question, "What's the rest of my life going to be like?" Windows allow her to preview the possible lives being led behind them. The artist, who is a widow, says, "I've always wanted to know what lies beyond."

Through her disarmingly simple painting, Ziegler-Schilling poses a philosophical conundrum. If everything were cheerful and gay, would we enjoy it? Doesn't it take the polarity of darkness for us to honor the light? Balancing polarities is an aspect of holism.

At their basic level of inspiration these artists share the same deep knowing that led me to found the Society of Layerists in Multi-Media: Nothing is totally isolated; everything is part of the whole. A sense of holism is gradually seeping into human consciousness. The holistic spirit is a personal discovery, but it affects society, politics, religion, science, health and art.

Within the first few decades of the new millennium I expect holism will mature into the dominant thought form. Should this be true, perhaps we can look forward as a race to lessening friction, to more successful problem solving and to expanded appreciation of imagination.

Layerists are helping build a bridge of transformation to a more benign level of consciousness. Once it has been reached, the distinctive presence we see in layered art—its manifestation of the holistic spirit—will be so widespread that SLMM will no longer be needed.

Editor's note: Mary L. Crest, Elaine Insero and Nancy Egol Nikkal have become full members of SLMM.

Dolores Ann Ziegler-Schilling, *Holiday Windows,* acrylic & collage/paper, 30 x 20

SIGNMAKERS

BY SUSAN HALLSTEN MCGARRY

"Layerists serve as perceptive scouts pointing toward an emerging synthesis of Eastern and Western thought, of science and philosophy, of art and the communal life."
— Mary Carroll Nelson, *Southwest Art*, April 1984

I first encountered Mary Carroll Nelson's visionary views while editing her article on the newly organized SLMM group for Southwest Art. Not only was it the first time I had heard the term layering, it was also the first exposure I had to the interconnection of Jung and Einstein's theories, which Nelson identified as at the heart of Layerist philosophy.

That article began a relationship and pattern of correspondence with Mary, whose letters I've saved in an ever-expanding file. As I review that file, I watch the growth of the group, as well as the ever-deepening layers of knowledge that inform Mary's own writing and art. From Hawaiian Shaman Training to studying England's crop circles to her seminal book Artists of the Spirit-New Prophets in Art and Mysticism, Mary has been a "perceptive scout" never content to accept the status quo.

Mary's drive toward emergence confronted me once again when I edited her April 1990 article titled "The Moving Spirit," in which she introduced me to the term paradigm shift. Although she was describing a specific group of transformative artists, Mary was once again serving for me and the readers of Southwest Art, as the "scout and signmaker for our culture" —

the phrase she used to characterize artists who believe that art can heal the individual and the planet. As she wrote, transformative artists "observe the world from a creative level of mind, they scout, just a little ahead of society, perceiving elusive evidence of where the trail is leading; and they make signs for others to follow."

Signmakers could easily be the subtitle attached to the Society of Layerists in Multi-Media, a group of artists that seeks to find within the known the unknown. Always restive, SLMM members explore uncharted internal and external landscapes, working "just a little ahead of society" in marking the trail that many of us seek in understanding the spiritual and physical elements of unity and multiplicity

Over my years of association with the SLMM, I have attended several of their conferences and traveled with them to England in pursuit of ancient spiritual sites. Invariably I return to my computer with newfound energy that expands like a lump of dough baked into a gloriously fluffy, browned loaf of bread. As I dissect and carve that loaf I see glimmers of the new millennium—transparent and opaque signs that hint at the mysteries of transformation.

They are the signs activating the drawings, paintings, collages and sculptures made by SLMM members. The personal glyphs and symbols reproduced in this book are universal signs that mark the heart of the human trail as it spirals outward, in harmony with our ever-expanding universe.

HISTORY
OF THE SOCIETY OF LAYERISTS IN MULTI-MEDIA

1982 - Incorporated in the State of New Mexico, May 13, 1982, Albuquerque, by Mary Carroll Nelson, with three directors: Alexander Nepote, Virginia Dehn and Martha Slaymaker.

1983 - Announcement of SLMM, *American Artist* April.

Summer meeting with original members and spouses: Alexander Nepote, Martha Slaymaker, Evelyn Rosenberg, Wilcke Smith and Mary Carroll Nelson.

Tax Exempt Status awarded on December 2, 1983.

1984 - Explanatory article about SLMM in "Viewpoints," *Southwest Art Magazine*, April.

June 22 - 24, first national meeting, Albuquerque, NM Film by Alexander and Hanne-Lore Nepote, "There is Much That Meets the Eye - Let's See It!," Talk linking metaphysics and SLMM's future by Dorothee Mella. Shamanic closing ritual by David Chethlahe Paladin, Navajo artist/shaman. Visits to Acoma and San Juan Pueblos, the New Mexico Arts & Crafts Fair.

Initiated Associate Membership.

1985 - "Layering, An Art of Time and Space," opened June 22 - Sept. 1, The Albuquerque Museum, curated by Mary Carroll Nelson. Catalogue of her interviews with artists. Talk at the Museum by Martha Slaymaker and Mary Carroll

Nelson on "The Philosophy of Layering." 72 members of SLMM. Meeting held in Albuquerque.

1986 - Richard Newman becomes president at annual meeting, October 25 - 26, Zanesville, OH, Juanita Williams, chairman. "Layering: Approaching the 'Layer' As a Formal Element and a Significant Metaphor in Art-making," by Mary Carroll Nelson, *Leonardo*, Vol. 19, No. 3, 1986, featuring Alexander Nepote, Richard Newman, Martha Slaymaker and Marlene Zander Gutierrez.

1987 - "Layering/Connecting," June, Zanesville Art Center, Zanesville, OH and the Stifel Fine Arts Center, Wheeling, WV, curated by Dr. Charles Dietz, with Mary Todd Beam and Sally Emslie. Catalogue designed and edited by Marilyn Hughey Phillis.

Meeting held at the ZAC, June.

1988 - Photo supplement published with May newsletter.

"Shrines and Sacred Places," featuring Richard Newman and others, curated by Mary Carroll Nelson, Keynote Exhibition for the New Mexico Arts & Crafts Fair. Meeting held in Albu-querque, June 22 - 24. Visit to San Juan Pueblo.

1989 - "The Art of Layering - A Creative Confrontation with Death," talk by Richard Newman to the Thanatology Symposium on "Reflections of Life and Death: The Art and Thanathology" in New York City.

Meeting held in Santa Monica, CA; chaired by Pat Cox arid Ruth Snyder. Visits to Fred Weisman home to tour collection, Los Angeles County Museum of Art, Ruth Snyder's studio and other points of interest.

1990 - "Layerists, Level to Level," Johnson-Humrickhouse Museum, Roscoe Village, Coshocton, OH, curated by Midge Derby, director. Marilyn Stocker, chairman, Sally Emslie, Jeny Reynolds arid Marilyn Hughey Phillis, committee.

"Layering," video featuring 86 members, produced by Schneider Creative, Mary Carroll Nelson, editor, with Hilda Appel Voikin, opening sequence by Richard Newman.

National Symposium, "Art and Healing," co-sponsored by *American Artist Magazine*, with a grant from The Robert Lee Blaffer Trust, New Harmony, IN, Oct. 26 -28, coordinated by Mary Carroll Nelson. Keynote: "Art, Healing, and Causality: Reunited in the New Paradigm," Willis W. Harman, Ph.D., president of the Institute of Noetic Sciences; "Birth, Death and Rebirth: The Creative Continuism," Richard Newman, president of SLMM, "Biopsychology in the Heart of Medicine," Leonard M. Wisneski, M.D., Coordinator of Medical Education, Holy Cross Hospital, Silver Spring, MD "Art, Society and Healing, Jerry Croghan, artist/author; Conclusion of the conference, by Dr. Joel Elkes, Director of the Division of Attitud-

inal and Behavioral Medicine at the University of Louisville, KY. Workshops by Rochelle Newman, Marilyn Hughey Phillis, Virginia Lee Williams and Marian Weber of The Healing Arts Center, Stinson Beach, CA. Personal healing experiences by Meinrad Craighead, Gilah Yelin Hirsch, Pat Musick and Beth Ames Swartz.

1991 - "The Society of Layerists in Multi-Media," Fuller Lodge Art Center, Los Alamos, NM, Patricia Chavez, Director.

"The Healing Experiience," Laura Knott Art Gallery, Bradford College, Bradford, MA, curated by Richard Newman, September. All art was the product of a sharing from studio to studio, in the format 12" x 24".

"Layering, A Gathering of Voices," Marin County Civic Arts Galleries, San Rafael, CA. curated by Lotte McWalters, organized by Pauline Eaton, October. Meeting in San Rafael, Pauline Eaton, Chairman.

"Layering, An Art of Time and Space", edited by Ann Hartley, published by SLMM, featuring the art and statements of 73 artists. (out of print).

1992 - "The Universal Link" and "Art is For Healing", University of Texas Health Science Center at San Antonio, curated by Delda Skinner. "The Universal Link," with a format of 24" x 24" presented works of partners who shared mementos. Work hung in pairs.

"Affirming Wholeness, The Art Experience," national symposium. Speakers: Jacob Liberman, "Light, Medicine of the Future," author of book of same title; "Making Connections, Spirituality, Art and Healing," by Mary Earle, Associate Rector, Reconciliation Episcopal Church, San Antonio, TX; "The Dance of Life," Eleanor S. Mc-Culley, R.N.,foun-der of Mobius, Inc.; "Healing the Healer," Mary Ellen Bluntzer, M.D., family systems physician and artist; Jeanne Achterberg, Ph.D. "The Healing Gift of the Imagination," Professor of Psychology, Institute of Transper-sonal Psychology, Menlo Park, CA; John Briggs, "The Universe as a Work of Art," Professor, Western Connecticut University. Work-shops by Richard Newman, Carole D. Barnes, Mary Todd Beam, Eleanor McCulley, Wilcke H. Smith. Meeting in San Antonio, chairman, Delda Skinner with Linda Hammond and Mary Ellen Matthews. Mary Carroll Nelson, consultant.

Establishment of the Mary Ellen Dwyer Memorial Fund.

1993 - "Layering," Dartmouth Street Gallery, Albuquerque, NM, curated by John Cacciatore, director, featuring 30 members.

Meeting, June 21 - 27, Albuquerque, NM. Mary Carroll Nelson, chairman with Suzanne Dunbar Caldwell Pauline Eaton, Hilda Volkin, Betty Rice, Cynthia Ploski, Wilcke H.

Smith, Victoria Martinez Rodgers and Meinrad Craighead. Week featured daily events and options for touring the State of New Mexico. Shamanic ritual led by Nancy Azara in the Jemez Mountains.

"Layering," works by Ohio SLMM Members, Denison Art Gallery, Denison University, Granville, OH, curated by Jane M. Cook and Jeny Reynolds.

Membership: 179

1994 - "The Layered Perspective," The Walton Arts Center and the Fine Arts Gallery,

University of Arkansas, Fayette-ville, Arkansas, October 3 - 5, coordinated by Betty Keisel, curators, Rebecca A. Johnson and Jacqueline Golden.

National Symposium, "Artists of the Spirit," Fayetteville, AR, based on the book *Artists of the Spirit*, by Mary Carroll Nelson. Speakers: Patricia Brown, Ph.D., Barbara Hand Clow, Meinrad Craighead, Gilah Yelin Hirsch, Pat Musick, Richard Newman, Miguel Angel Ruiz, Peter Rogers and Melissa Zink.

"Southwest Visions," Regional Exhib-ition, Johnson-Humrickhouse Mu-seum, Roscoe Village, Coshocton, OH, coordinated by Dorothea Bluck, Marilyn Stocker and Juanita Williams. "Crossings," Laura Knott Art Gallery, Bradford College, Bradford, MA, curated by Richard Newman, September.

"SLMM Members' Group Exhibition, New Mexico," Fuller Lodge Art Gallery, Los Alamos, NM, curated by Patricia Chavez, director.

1995 -"Layers of Life," Reynolds-Heller Gallery, Columbus, OH,

OH Regional Tour Suitcase Show, conceived by Mary Beam, curated by Jeny Reynolds and Jane Heller

"Crossings," Greeley, CO, June, organized by Lydia Ruyle.

"Crossings," St. John's College, Santa Fe, NM, July, organized by Ilena Grayson. Meeting in Greeley and Denver, CO, coordinated by T. F. Poduska. Speakers: Ron Russell, United States Director of the Centre for Crop Circle Studies, Bonny Lhotka with demonstration of Digital Art, visits to print and artists' studios, Denver. Tour of Marilyn Markowitz's studio, Boulder.

1996 - "The Tree of Life," Instituto Allende, San Miguel de Allende, Mexico, Suitcase Show, organized by Ilena Grayson, June. Work carried to Mexico by artists.

First International Meeting. Tour of Guanajuato, tour of Teotihuacan with Miguel Angel Ruiz, organized by Mary Carroll Nelson and Marilyn Christenson.

"Layers: Mining the Unconcious," Western New Mexico University, Silver City, NM, curated by the Art Department, September. "Crossings," The Open Art Center, Old Saybrook,

CT, organized by Marlene Lenker, see 1994.

1997 - "Guardian Spirits," St. Peter's and St. Paul's Church, Marlborough, England. Suitcase Show, organized by Ilena Grayson, hung with help from Isabelle Kingston and Ingrid Leeds.

Second International meeting, coordinated by Mary Carroll Nelson and Marilyn Christenson, with tours of Stonehenge, Avebury, Salisbury, Glastonbury and Cornwall. Talks by Simon Peter Fuller and Isabelle Kingston.

1998 - "Celtic Connections," curated by Richard Newman, Laura Knott Art Gallery,

Bradford College, Bradford, MA.

Meeting, October 14 - 18, Haverhill, MA. Tours and sharing of region. Publication of *Bridging Time and Space, Essays on Layered*. Ann Hartley, Editor. Preface by Richard Newman. Foreword by Mary Carroll Nelson. Afterword by Susan Hallsten McGarry.

Membership: 275

1999 - "Bridging Time and Space," Exhibition, Dominican College, San Rafael, CA. Meeting with speakers and workshops, Juliet Wood, chairman.

2000 - Meeting and exhibition, "Millennium," Albuquerque, NM. Organized by New Mexico members of SLMM.

INDEX
ARTISTS & PLATES